NORTH LIGHT BOOKS
Cincinnati, Ohio
CreateMixedMedia.com

THE ART OF MiSTAKES

Unexpected Painting Techniques & the Practice of Creative Thinking

melanie rothschild

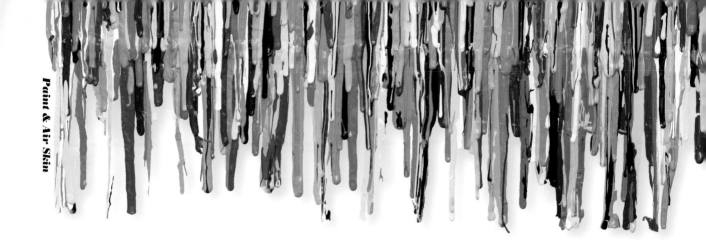

CONTENTS

A NOTE

Although wonderful "art inspiration" books exist, most of them offer a step-by-step method. My approach is quite different: Rather than propose a how-to guide for creative thinking, my goal is to present an overall "unlocking of the creative spirit," believing that once the case for "artistic confidence" is made, the actual steps will largely fall into place. An analogy can be made to lovemaking: Once the passion is ignited, the actual details follow accordingly.

It is perhaps, a pre-step-by-step guide.

materials used

acrylic paint

burnisher

craft knife

dimensional fabric paint

fan brush

high-quality masking tape

latex paint

liner brush

paintbrushes in a variety of shapes and sizes

painter's tape

scissors

self-healing cutting mat

thread

variety of mark-making or stamp-making items (rolling pin, paintbrushes)

wooden boards or canvases

Rocco

PiNK FROGS: AN iNTRODUCTiON

One interesting thing about life is that you never know when, out of nowhere, something is going to happen that will imbed itself in your gut.

Several years ago I was doing an art show, and a woman came over to me and asked if I could recommend an art class for her young daughter. Apparently the girl was very excited about taking an art class outside of school, but after giving it a try, things took an unexpected turn. The girl had done a painting with a pink frog, of which she was quite proud—at least until the teacher explained to her that it was not acceptable.

The reasoning was straightforward: Frogs are green, not pink. Therefore, all would be well if the child would follow the teacher's simple directions and change the coloration of her small, misguided amphibian.

The young artist was devastated. She'd had a plan. She couldn't understand why she wasn't allowed to follow through with her vision. She'd been looking forward to an art class, a place where she'd be able to "live out loud" as her inner artist self, and this was not what she'd been expecting, not in the least.

The chilling part for me wasn't really about this little girl; she was lucky to have a mother with enough clarity of thought to see the potential damage that lay ahead and to take pains to redirect her child from this "spiritually toxic" situation. I just couldn't stop thinking about all the kids with parents who would defer to such a teacher or with parents who would admonish a child for this sort of irreverent behavior.

It made me think about why people send their kids to art classes, or why, for that matter, any of us take art classes.

Certainly there's a lot to be learned: drawing, shading, perspective, crosshatching, sculpting, carving, molding and endless other wonderful skills that can develop lifelong tools for artists. But right in the center of the artist's essential tool kit is one tool, arguably the most essential of all, that is easily forgotten in the dedication to attain perfection: becoming adept with the ecstasy of creating unruliness and understanding the profundity of that knack. It's the sweet spot—the intersection of art, imagination, new ideas and progress. This kind of understanding is possibly the most important reason for doing art at all. Maybe it's even the reason that art exists.

From a parent's point of view, isn't art the place where you want your kid to be bold and take chances? When you consider all the other kinds of risky behaviors out there, I think the art class is a pretty swell place for adventure.

I meet so many adults who talk about how much they wish they could do art but are rotten artists. Many of them say they have proof that they have no talent and often recount stories about some experience where a teacher or some authority figure told them that their work was not acceptable. Those feelings were internalized and *poof!* . . . they long ago bought into accepting someone else's judgment, and it has shut them down for years, maybe decades, or even forever. It all made me think . . . an art class can be a dangerous place.

I am self-taught and hold the notion of the creative spirit very dear. I am exponentially grateful that my own creative force managed to flourish amid a world of "shoulds" and "shouldn'ts." In appreciation of that good fortune, I have written this book with the intention of inspiring or, even more significantly, giving *permission* to those who may be unschooled but who are innate artists and have a creative burn sweltering inside of them.

So many people I encounter are intimidated by art because of a lack of formal training. I believe that for many artists, lack of training is not a disadvantage. It can actually be an invaluable asset. Understanding and appreciating this concept can be a momentous realization for artists and those who dream of being artists. It's a mind-set that can ultimately be deeply meaningful and yield much more creative juice than any particular technique.

In my own case, I came to paints and other materials without training, without any rules pounded into my head about how things are supposed to be done. I started by doing whatever I could dream up with no thoughts dancing around saying to me, *Oh, you can't possibly do that. That's just not how it's done.*

I'd been to college but didn't feel I had any place in an art department—that was for the talented, not the dabblers. I majored in ethnic arts (think anthropology + indigenous art).

The kind of tribal art I studied academically touched me. I became absorbed with textiles from Thailand, African masks, Native American pottery. I loved the idea that in these cultures, art was for everyone. It wasn't separated in museums or cloistered in private for the upper crust. In these societies, art was part of life, and people knew and understood the fabulously decorated artifacts used in ceremonies and rituals.

I saw that people all around the world were driven to create some sort of art. I saw that the drive to do so was apparently a basic instinct, and I found it deeply inspiring.

I was lucky enough to be at an intersection in life where I had a strong dose of devil-may-care attitude, a rich body of design references in my head from cultures all around the world—not just the ones society deemed an appropriate part of "art history"—and an abundance of picture frames due to a family business.

Arapahoe Boxes

I believe that for many artists, **lack of training is not a disadvantage.** It can actually be an invaluable asset.

Zelmar

Somewhere along the way, I started playing around with painting the picture frames. I suppose the formal term would be "decorative painting," but as far as I was concerned, I was just fooling around, making designs on something that was in abundant supply. I didn't have any actual instruction, and I didn't know what I was doing, but I liked what I was doing, and I was having a lot of fun delving into the paints and devising all sorts of guerilla techniques. Inspired by the multitude of ways that people all over the world go about making art, using whatever is available to them, I was using not only brushes, but the handles of broken brushes, the edges of cardboard, a rolling pin—just about anything within arm's reach that I could find to apply paint.

Eventually I was painting like crazy. More and more designs led to more ideas. More ideas led to more techniques, and I was in a blissful state. I had amassed enough work that I could take a step back, look at what I'd made and recognize distinct design categories. In each of those categories, I was then able to refine some of the ideas. I developed an array of designs I was proud to show.

I decided to apply to a weekend art show at a local park and was accepted. I put my frames out, and people bought them. I also had a couple of people ask if I did wholesale orders. At the time, I didn't know exactly what that was, but I knew that it sounded like a good thing. I said yes. Soon I had wholesale orders to fill, meaning that the work would be bought and then put into stores to be sold to the store's customers.

From talking with other artists and vendors, I learned about trade shows, which are shows where all the purchases are made by store buyers to resell in a retail setting. These shows were much more intense than the art shows in the park. They're expensive to do, often far from home and there are very specific and often rigorous rules about display, but they offer the potential to garner substantial orders. The deadlines that come with such a weighty situation are powerful, but they can also be a potent mechanism for propelling new work.

Inspired by the multitude of ways that people all over the world go about **making art,** using whatever is available to them, **I was using** not only brushes, but the handles of broken brushes, the edges of cardboard, a rolling pin— **just about anything within** arm's reach that I could find to apply paint.

Polito

Micheltorena

Rocco

It was scary but also invigorating. Knowing that there'd be hundreds of people coming to see my work who'd be considering it for their stores energized me to create more and more choices. It was a joy to understand that my "messing around time" was actually my "work."

It was also great fun to put all the work into a single comprehensive display. Having it all together was not only satisfying, but it helped me to see it from new perspectives. I saw broad groupings of designs and colors that I hadn't actually planned but that gave me ideas for how to think about the work. I could consider it in terms of color: bright colors, neutrals, soft colors for weddings or for babies. Another way to perceive it had to do with the nature of the designs: geometrics, stripes, loose brushwork, heavy textures. It was interesting to think about putting my work into categories at all.

With all these various permutations, I thought about and looked at my work in many more ways. The more categories I saw, the more ideas they spawned. The more things sold and the more customers who bought from me regularly, the more energized I was to create still more. After a few years, I'd developed a strong base of customers from across the country. They thrilled me not only by their loyalty in buying

my work, but with their enthusiasm every time they ordered. **It was all just "stuff I made up," but people took it seriously and bought it again and again.**

After about ten years of successfully selling my work, I decided it was finally time to take a "real" art class. I kept thinking that if things were going well without my having any training, then just imagine what I could do if I had formal instruction. **In fact, I felt I owed it to all my loyal customers to finally learn how to "do things the right way."**

I signed up for a painting class—the real deal. Now I'd finally have the chance to make myself legitimate and become a "genuine" artist.

On the very first night, the teacher told us that the most important rule was not to mix acrylic colors. What?! I'd been mixing acrylic colors all along and, in fact, had always been told how much people responded, in particular, to my colors! Should I raise my hand and let it be known that it actually could be done? No, I couldn't do that. I must have been wrong somehow.

Then there was more talk about brushes—different brushes for various techniques. I was told that I didn't have an adequate amount of brushes on hand to create all the possible effects and was advised to buy specific brushes. Did you really have to have all those exact brushes to be a good painter? What if you wanted to try something else, to make something up, if you wanted yours to be different from the others? What to think? What to do? This was expert advice; how could I refute it? But then again, how could I ignore what had worked so well for me for so many years?

It was a joy to understand that my "messing around" time was actually my "work."

Iredale

Why I Hate One-Size-Fits-All (and Love Stretch Denim)

I think the very term *one-size-fits-all* is dodgy. It plants the idea of "one way-ness," when for most things in life there are many, many ways to achieve, measure and value the things we do. One way might be a good fit for some people some of the time, but how can just one size really be considered a viable form for all?

Stretch denim, however, offers a much more livable and, I believe, apt model for thinking: It presents a sturdy framework, along with some wiggle room, and in the end, it treats us with respect because it doesn't overpromise.

The two concepts represent a fitting picture for thinking about our own creativity. If presented with a particular set of directions for how to go about exercising your own creativity, I'd warn: Beware of one-size-fits-all approaches.

Although any method might be a good fit for someone, I believe that rather than a single how-to approach, enhancing creativity relies on some fundamental understandings. Once those understandings (the sturdy framework) are integrated, I feel there's a tremendous amount of stretch in how the specifics can be undertaken.

So often we encounter instructions that tell us we must proceed in this or that particular manner in order to achieve the "correct" result. To take a basic example, I love to cook, and I certainly acknowledge the need for recipes. However, I rarely, if ever, actually follow the instructions as written. To me, the vital element, the satisfying part, is my own creativity, my own take on the dish. But here's the rub: It's relatively easy to give oneself permission to "stray" when the issue is food. After all, the proof, as they say, is in the eating, and if the result tastes good, you have a tangible indication that it was okay to wander. It's much more of a problem, however, when we're not dealing with something as concrete as cooking. In many areas of life, and in particular the arts, it can be much more difficult to ignore the rules, to abandon the one-size-fits-all approach, for fear that we're not "doing it the right way."

I'll use chicken soup as a metaphor for illustrating this elastic approach to creativity.

Could it really be that there's just one absolutely perfect recipe for achieving the best chicken soup the world over? Can anyone seriously uphold the idea of one divine method for attaining culinary perfection with this dish and all the others being second-rate also-rans? Of course not.

Depending on readily available resources, individual tastes and lifelong conditioning, the range of preferences for what hits the spot is vast. There is a basic structure: a flavorful stock, along with some amount of chicken and other ingredients like vegetables (and maybe something like rice or noodles).

But how could we really consider there to be a single best form of this venerable dish? I've heard declarations of the finest version of chicken soup to be one that contains freshly chopped cilantro sprinkled on top. Yet my own husband runs at top speed from anything with even a hint of cilantro. (Personally, I quite like it.) All of this is to say that the idea of a one-size-fits-all or best methodology for most things is, I believe, dramatically overpromised.

I suppose that one-size-fits-all models might be helpful some of the time, although I'll admit that I'm not able to come up with a single example. But the idea of acknowledging an underlying structure (the basic components of chicken soup), rather than rigidly adhering to a particular ingredients list, sets you up as an independent soup diva. Combining tasty stock, some chicken and a gathering of veggies leaves a lot of room for movement, exploration and discovery. And just as with making your own art, or any sort of creation you'll want to call your own, the same idea applies: **The fun and satisfaction is in taking the basic structure and playing with all the ways you can stretch it to find just the right fit . . . for you.**

Please visit createmixedmedia.com/the-art-of-mistakes for bonus content.

I think the very term one-size-fits-all is dodgy. It plants the idea of "one way-ness," when **for most things in life there are many, many ways to achieve, measure and value the things we do.** One way might be a good fit for some people some of the time, but how can just one size really be considered a viable form for all?

Bixler

Chaccone

I'd actually been making a living selling these picture frames— frames with mixed acrylic colors and techniques using sticks and thread and rolling pins, not fancy brushes. As I spoke with some of the more experienced students in the group, I gradually noticed that I was the only one in the class actually earning my living with my art. Even the teacher had another job. If these much more advanced students were artists but not selling their work, and I wasn't a "real" artist but was selling my work, then just what was I? What did it mean to be an artist? Who and what in the world was I?

But mostly I kept thinking, what would have happened if I'd taken this class ten years earlier? I never would have felt at ease with all my puttering and meandering, which led to all my wacky techniques. I never would have developed the ideas and the designs or the business that had come to be such a significant part of my life.

It was a huge moment for me when I realized that my lack of training was actually a big plus for pursuing a truly individual path. How lucky. Dumb luck. That night I went home and wrote the outline for this book: I realized that an art class can indeed be a very dangerous place. It can give the false impression that there are indispensable rules, rules that must be closely followed in order to achieve the desired effect. Problem is, having clarity about the ultimate goal in studying art can get tragically mangled.

Single-mindedly concentrating on a given set of instructions may lead to mastering a particular technique. But if the learning of a technique unintentionally lays down boundaries in such a way that experimentation with other ideas is thwarted, then we might be achieving the creation of a product, but what's being taught is something other than creating art. And the price paid for learning that method might just be the obstruction of an inherent creative spirit.

It was a huge moment for me when **I realized that my lack of training was actually a big plus for pursuing a truly individual path.** How lucky. Dumb luck. That night I went home and wrote the outline for this book when I realized that **an art class can indeed be a very dangerous place.**

Noe

In general, I'm a pretty polite type and a rule follower. I just am. "Everyone, please be quiet." Done. "Please fill this out and go back to the end of the line." Again, done. And so in art class, my tendency was always to fall in line, again. I wanted to do things the right way and to get a good result. I couldn't bear the idea of being thought of as uncooperative, and certainly I wanted the teacher to think well of me.

This is where the gift of time on earth, also known as age, comes into play.

Somewhere along the way between eighth-grade art class and my first signs of graying hair, I realized that what the teacher thought of me didn't really matter.

Certainly having had success selling my work for years emboldened me to trust my own instincts and experiences. **But it still felt odd to be in a class and not to defer to the authority in the room. I'd been so conditioned to rely on the teacher's opinions.**

Then I thought about the people who were buying my work. Some were people who were buying work for themselves. Others were placing orders for their own stores or for the management of stores that trusted them to make buying decisions for multiple locations. In either case, these people seemed to be full of enthusiasm for the colors I was mixing. Over and over again, people talked about how much they liked the colors I used, even though mixing acrylic colors was officially frowned upon "in class."

Tivoli

I was always thrilled by color. Mixing colors was simply full-out joy for me. I loved putting together all the endless combinations, and it made me feel so good that others responded to my passion for creating and joining colors.

Realizing that I didn't really care what the teacher thought of me was like taking a ride in outer space.

TEACHERS, TAKE NOTE:

People who are in a role of regularly delivering opinions should probably be licensed. At the very least we would all benefit if they had serious training to sensitize them to the critical role they play in the creative lives under their jurisdiction.

If you teach or are somehow in a position to offer criticism to developing artists, please take seriously the massive power you may have in shaping and affecting the creative energy in your students. Finding ways of offering criticism that maintains a student's zeal may be a crucial component in nurturing or crushing his or her evolving creativity.

My dear friend Inez, when she was alive, used to visit me all the time in my workshop. She had a wonderful phrase she'd use to set up the conversation when something didn't appeal to her . . . A phrase that still enabled me to maintain my excitement for whatever the piece was:

"It doesn't speak to me," she'd say.

Over time I came to realize what a brilliant and nuanced expression this was. It conveys another outlook, a new perspective which at times can be very helpful, but without harsh judgment, without squashing enthusiasm. It communicates the basic thought while leaving the maker's exuberance intact.

IF YOU FIND YOURSELF UPSET BECAUSE YOU BELIEVE A TEACHER ISN'T IMPRESSED WITH YOUR WORK, YOU MIGHT CONSIDER A FEW THINGS:

- Do you understand what the teacher is saying about your work? If not, it's probably a good idea to say that and ask for more explanation.

- Is there anything about the feedback that you feel could be useful in enhancing what you're doing? (This is the tricky belly of the beast.) Maybe there's some genuine value in the feedback. Certainly there's value in maintaining the teacher's sensibility—at least for the teacher. And this is where the deep down, taking a hard look at what you're doing and what you want to do comes in: Is maintaining the teacher's sensibility meaningful for you? The answer might be yes, but it's a decision-making process that requires ongoing and extensive thinking and intentionality. **The whole activity of considering what you want—accepting and rejecting the opinions of others—that is the very hard work of being an artist.**

Ultimately what does it matter what the teacher thinks about your work? Really, why is that important? Years from now, only you and your work will be associated together. The teacher will have long forgotten about you.

Polito box

Frenchy Box

Don't get me wrong. I still care about conducting myself politely, with kindness and respect. It's just that at some point, it occurred to me that I couldn't let "good conduct" get in the way of how I want to make my art. **I wasn't willing to politely just accept whatever opinion was being served and to ultimately have it hijack the essence of me out of my own work.**

So maybe you take all your courage and sign up for an art course. Maybe you get lucky and connect with a class and a teacher and a setting that helps you unleash what you know—or at least hope and suspect—is inside you. Or perhaps you buy a book that takes you through some liberating steps.

If that's the case, then hallelujah: You have *scored* in the artistic/spiritual sense.

But what if this class or book doesn't leave you feeling how you'd hoped you'd feel after this tremendous leap?

A few too many rules about what to do, what to buy, what not to do and, *poof* . . .

You're in artistic lockdown!

You need permission—permission to do what's gnawing at your insides but what you might not think is OK to do. How can you get permission granted?

BONUS ○ ○ ○ ○ ○ ○ ○ ○ ○ ○ ○ ○ ○ ○ ○
Watch a video interview of Melanie talking to her editor about mistakes and why an art class can be a dangerous place at createmixedmedia.com/the-art-of-mistakes.

Inee

20

Please visit createmixedmedia.com/the-art-of-mistakes for bonus content.

Realizing that I didn't really **care** what the teacher thought of me **was like** taking a ride in outer space.

Odette

Relax: The Art Police Do Not Have
the Authority to Arrest You

pages 22 & 23: *Veselka*

A lot of things are decided for us in life before we even arrive on the scene. The time in history in which we land, the location where we're born, our gender and the circumstances of the family in which we grow up are all settled for us before we get to make a peep. After that, there are plenty of rules we need to learn—most of them are for our own good—to keep us safe and healthy. If we're lucky, we get to eat things we like and choose what we want to wear. Still, for many of us, for a long, long time, our lives are largely determined by other people's decisions: School, homework, the music we hear, possibly religious practice, chores and other cultural norms regulate our lives. Art is an oasis, one where we're in charge of our own thinking and our own potential. That's sacred territory. **Unthinkingly allowing others to determine how our art should or shouldn't take shape is like handing over a part of our souls we may later realize shouldn't have ever been negotiable.**

People engage in all sorts of risky behaviors, even though they know there are often horrible consequences. Excessive drinking, drug use, unsafe sex, gambling—just to name a few—can all have quite devastating effects, yet people still pursue them with gusto.

Oddly enough, art, which has no horrific risks associated with it, is a realm into which many will not dare enter. It's actually pretty fascinating. People who might try all manner of other risky activities will often freeze in the face of expressing artistic desires or impulses.

There are lots of excuses of course: lack of training, lack of time, lack of talent. But I believe that most people who have artistic inclinations, yet are afraid to really jump in, are haunted by the memory of some teacher or "expert" somewhere down the line who made a less-than-flattering remark about their artistic efforts. Maybe a negative comment was made about someone else's work, but it was enough to plant a message down deep: *Don't try this unless you're one of the chosen few. You have no business here.*

People who might try all manner of other risky activities will often freeze in the face of **expressing artistic desires or impulses.**

Iredale

THE ARTiFiCE OF DEPTH

Don't ever let anyone art-bully you. Art criminals exist outside of the classroom, too.

There are lots of reasons why art can feel intimidating. I believe that most of those reasons have developed in a context where people find tremendous personal gain in creating a hierarchy—one where they're in and you're out. It builds exclusivity.

This perceived exclusiveness benefits two general agendas: status and money.

Some might call such practices a crime, others a moral sin. Regardless of the specific name, the underlying principle is that anything in any form that makes onlookers feel they don't "belong at the art table" is an art felony. I consider it deadly because it has the power to kill creative initiative. People buy into the notion that they're outsiders who have no right to step into the "inner circle," and so they stay away, often forever. Now that's a crime.

If you've ever read an explanation about a particular exhibit or an artist's work, and it's left you feeling like you're completely out of the loop or not up to the task of understanding what's going on, please remember this: It's probably not you.

If written well and with the intent to truly communicate, pretty much any concept should be able to be made understandable. By the same token, no matter how simple, any concept can be written with the intent to create an air of elitism and crafted into an incomprehensible, obtuse compilation of verbiage, sometimes referred to as "authority through obscurity." (see sidebar)

TWO VERY DIFFERENT APPROACHES TO ARTIST'S STATEMENTS

Sometimes it seems as though it's almost a requirement that explanations about art be virtually incomprehensible.
Sample A:
Questioning verifiable truths and exploring the boundaries between the known and the yet to be known, we experience the nuances of investigation, literally as well as metaphorically. The tragedy of assumption holds hostage the potential. The discourse traverses the intersection between borders real and imagined.

Here's another approach to writing about the very same piece of work.
Sample B:
In this piece, *Paint & Air II*, paint is used simply as paint—it hangs in the air without any canvas. I like to use traditional materials in new ways.

I believe it's the job of artists to remind people to be open to thinking in different ways about things that we think we already know. Being open-minded is at the heart of what drives the human race forward, and artists are the ones who need to keep reminding everyone of that.

If you've ever read an explanation about a particular exhibit or an artist's work and it's left you **feeling like you're completely out of the loop** or not up to the task of understanding what's going on, please **remember this:** **It's probably not you.**

Tecata

I meet people all the time who talk about how much they love art but how lousy they think they are at it—and many of them tell stories they offer as "proof." It's amazing how those messages we hear as children can jump into our psyches and lodge themselves deep down.

Art, a divine expression of the human creative force, has somehow fallen into the anointed hands of untouchable experts. We are surrounded by opinions that we dare not challenge any more than we'd acknowledge the sight of the unclothed emperor. Yet these pronouncements all too often rule the day and keep cloistered untold reserves of creative spark. What a loss!

If we can reconfigure our perspectives, even slightly, we can take back ownership for our own creative force, undaunted by the ominous pointed finger of the royal decision makers.

Guten Tag Hall of Fame

Please visit createmixedmedia.com/the-art-of-mistakes for bonus content.

Art, a divine expression of the human creative force, has somehow fallen into the anointed hands of untouchable experts. We are surrounded by opinions that we dare not challenge any more than we'd acknowledge the sight of the unclothed emperor. Yet these pronouncements all too often rule the day and keep cloistered untold reserves of creative spark. What a loss!

Sassafras

Just about anything can be artificially pumped up with carefully chosen language in order to create an illusion of depth.

I believe that "The Emperor's New Clothes," by Hans Christian Andersen, delivers such an important message that it should be part of any bible. In a nutshell, the story is about two tailors who promise the emperor that they can make him the most splendid suit of clothes. They further promise that the clothes will be so very magnificent that they will appear as invisible to anyone who's too stupid or unworthy of appreciating the ultra-superior quality of the goods. The king, who doesn't see anything at all when he is finally presented with the alleged garments, is so worried about being thought a fool that he withholds his genuine response.

Left with no good options, he eventually finds himself in the tricky spot of having to parade through the town in his "new fancy duds." While he in no way is enthused about stepping out before everyone in the buff, he's more fearful of admitting that he doesn't see any clothes and being considered a fool, unworthy of his high office. **He banks on the idea that he doesn't see something that everyone else can.**

The townspeople, afraid to be insubordinate to His Highness, go along with the charade. It isn't until a little child in the crowd cries out, "The king is naked" that everyone regains their grip on reality.

(You might consider reading it to yourself regularly at bedtime.)

The entirety of Judeo-Christian morality has been pared down to ten essential, understandable points in the form of the Ten Commandments.

If it were up to me, I'd add another:

Thou shalt not make anyone ever feel excluded from the exuberant gift of art because it belongs to each and every one of us—one of the best perks of being a human being.

Frenchy on Grey

Tattoo

Please visit createmixedmedia.com/the-art-of-mistakes for bonus content.

11th Commandment.

Thou shalt not make anyone ever feel excluded from **the exuberant gift of art** because it belongs to each and every one of us—**one of the best perks of being a human being.**

Izzy

Don't Yuck My Yum

Amaretto

Once at a potluck party, I heard somebody say, "Don't yuck my yum," and I haven't been able to get over it since. And while it was about food (the answer, I suppose, to "You're going to eat *that*?!"), I immediately saw it in a wider context. It's beautiful . . . the statement has everything I believe good art should have: somehow appealing, readily understandable, yet with layered meaning, reminding us that we can think for ourselves. It's a gem. And even though it's actually about food, it can just as easily be about art or music or hiking or pretty much anything else. (And maybe we shouldn't even try to distinguish art from food or any of the aforementioned categories.)

Don't yuck my yum = don't rain on my parade. If I'm grooving on something, be it food or a movie or a piece of art, just let me revel in the relish. But why? What's the big deal about piping up if you don't like something?

Well, according to creativity research, it is very much a big deal: **Nay-saying of the too early and too hearty variety can pollute the creative climate.** It can be like putting on the brakes before the engine even gets into motion. Putting the kibosh on the subject at hand can sully enthusiasm, which is often all too elusive to muster in the first place.

Of course, this doesn't mean that no one can ever dislike something or venture a criticism. It just means that there's a time, a place and a way to express those opinions. It's a call to take seriously the sacred nature of passion and what I like to call "the fragility of zest."

Respect
the fragility
of zest.

Alma

Academy Awards and Art and Life

I think the Academy Awards are a funny thing. To be really honest, I think they're nuts.

Don't get me wrong. I love the red carpet and seeing all the razzle-dazzle outfits. It's what happens afterwards, inside the auditorium, that leaves me scratching my head.

The decisions of the Academy magically take on a particular type of absolute truth, which seems to exist in few other places. In our democracy, we have elections with winners and losers, but even the winner is under constant judgment and scrutiny.

Yet it's not at all uncommon for people to refer to the "Best Picture of the Year" as if it were some sort of absolute fact, like the law of gravity. Winning an Oscar seems to shut down or discourage real discourse about movies. The winners are beyond challenge because, well, they won.

I don't know how often people temper these perceptions of "absolute best" with the knowledge that the Academy Awards were started in the 1920s by MGM's Louis B. Mayer to elevate the image of the film industry. It's an industry that hatched a remarkable plan of giving *itself* public awards, and the whole thing has taken on an amazing life of its own. As a marketing plan, it's sheer brilliance!

I've often thought of giving annual awards to my own art. Here are some of the categories I've contemplated:

- Work of Which I'm Most Proud
- Most Colorful
- Most Dramatic
- Most Inventive
- Best Overall Work

And on and on. If I were to make official-looking ribbons and attach them to the work, I've often wondered if those accolades would actually make an impact on sales. I'm guessing they would.

I love the movies and am constantly in awe of the talent of actors, both high-profile celebrities as well as so many virtually unknown people. I just find that conversations that refer to Academy Award records of particular films or actors are far less interesting and satisfying than those conversations that are more specific and delve more deeply.

Many times I've heard people express their enthusiasm for a movie by saying something like, "It was so good. I think it's going to win the Academy Award." Yet I think it's interesting to note that *The Wizard of Oz* did not win the Academy Award for best movie, and neither Cary Grant nor Alfred Hitchcock ever received Oscars. How accurate a measure can a system be that allows this? And why do we keep referencing it as the ultimate way to laud a movie?

I think all of this is a particular kind of opportunity. I see it as a reminder to think about how we form our ideas about what's good or what we consider "the best," both in our own work as well as more widely seen work. How we make decisions about what we like and the truths that we integrate about work we revere should be made with care. Forming our own conclusions is certainly an integral part of the pleasure in enjoying any art.

Ultimately the decision should be authentically up to us.

Please visit createmixedmedia.com/the-art-of-mistakes for bonus content.

How we make decisions
about what we like
and the truths that we
integrate about work we
revere should be made
with care. **Forming
our own conclusions
is certainly an integral
part of the pleasure in
enjoying any art.**

Rocco

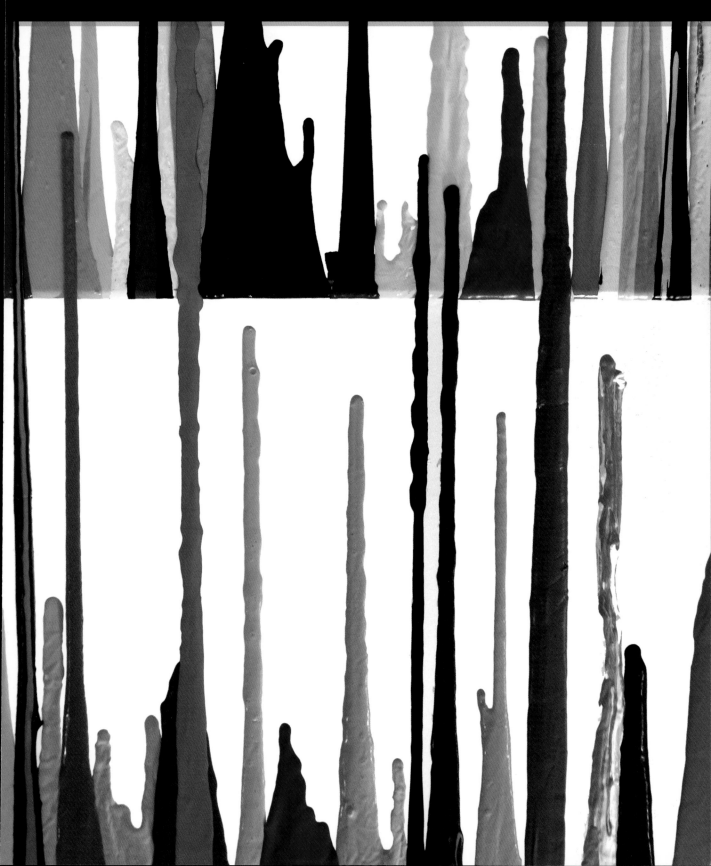

Reevaluate Your Relationship With Mistakes

We are taught to avoid mistakes. This across-the-board opposition to mistake making is seriously shortsighted. Mistakes are much more nuanced than we generally consider them to be. **Understanding the organic role of mistakes in the creative process may be the single greatest thing we can do to connect with a genuinely creative sensibility.**

When it comes to mistakes, we're all experts. Really. Anyone capable of constructing a compound sentence can talk to you about their experience with mistakes. Yet, fear of making mistakes massively holds us back from trying new things. Fear of making mistakes massively holds us back from trying new things. That was not a mistake. It was written twice because it is a salient point.

Mistakes are inevitable. They are so much a part of the human experience that even small children can talk about them from a qualified vantage point. **The entire evolutionary process rests on a dance of mistakes and new directions.** In general, making mistakes brings us to the point of new thoughts and information.

Mistakes give us ideas that we could never deliberately think up otherwise. Yet, we are misguidedly programmed to steer clear of them . . . at all costs. And most of the time, the price we pay for avoiding mistakes is the loss of stretching our thinking in substantive, new ways. **There are serious consequences for not understanding the nature of how mistakes serve us.**

A few years ago, I had a seemingly innocuous experience that turned out to be quite profound. I accidentally spilled a whole gallon of paint on my workshop floor. Not wanting to clean up the mess at the time, I decided to let it dry and chip it off bit by bit later on, after it had dried and would be less messy to clean. When I returned to it a few days later and started to chip it away, instead of it breaking off in small pieces, it came off in one glorious piece, absolutely stunning me. This is what spawned the idea for the series I call "Paint and Air." It consists of purposely spilled paint, dried and peeled up, that hangs from metal armatures in the air. It completely changed the direction of my work and has absorbed me entirely for the last several years. **I realized that I never would have come to this idea if it hadn't been for the mistake of spilling the paint.**

Certainly there are mistakes we don't want to make. Those should be pretty obvious: You don't want to make a mistake when you're merging onto a bustling freeway, and you certainly don't want your surgeon feeling free about mistakes while standing beside your anesthetized body with a knife. Clearly not all mistakes are cause for celebration, nor are they the awakening of a new dawn. Some mistakes are awful and scary and cause pain and misery. Bad mistakes are real things. But not all mistakes are bad mistakes. **Learning when mistakes matter and when mistakes are not so bad and may even have real value is a critical skill.**

Puddle Painting

Being able to navigate smoothly between the **OKAY TO MAKE MiSTAKES** and **DON'T WANT A MiSTAKE HERE** zones is perhaps the talent we most need to perfect in connecting with our creative strength.

Micheltorena

PERMISSION GIVER

As an adult, I once had a teacher, Dr. Mary Murdock, who gave every student in the class a strip of amusement park tickets. She said that whenever we made a mistake in class, we were to tear off a ticket, drop it in the big box she had set up and, with that action, absolve ourselves of whatever we perceived the mistake had been.

At first, it seemed like a pretty silly exercise. But little by little, I started to get into a slightly different rhythm. I sensed I could do things and try things, which I realized I somehow would have otherwise held back on, even if it were just holding back a little bit. As time went on, I began to recognize just how often so many of my inclinations were unnecessarily held back by unconscious gatekeepers.

When I started to run low on tickets I got a little panicky. Eventually of course, I realized that I didn't need to be holding actual tickets in order to give myself permission. The power was in my own head.

Oozeman

Please visit createmixedmedia.com/the-art-of-mistakes for bonus content.

Paint & Air Chandelier

The real art comes in learning how to make the judgment call about when a mistake might be something to definitely avoid as opposed to when a mistake might be a darn useful thing. **The problem comes when we decide that mistakes should be eliminated across the board and we hold ourselves back for fear of making a mistake when there really isn't much at stake at all.** Being able to navigate smoothly between the "okay to make mistakes" and "don't want a mistake here" zones is perhaps the talent we most need to perfect in connecting with our creative strength.

Of all places, art is a spot where **mistakes should be considered honored guests.**

Bo

The golden moment from mistake making comes not just from the making of the mistake but from the ability to recognize the opportunity that has been presented. The expertise is in developing the astuteness to identify the value of the moment, when others would unthinkingly dismiss it. The term "happy accident," which is used as a quick way to discuss mistakes, often overlooks this nuanced but very crucial understanding. Just because a mistake has been made does not mean that its benefit has been understood. Having the ability to perceive the "golden moment" in a mistake is where the proficiency lies. Cultivating the perception, the preparation to seize the moment when it occurs should be at the heart of the artist's training.

When we come to understand deeply that mistakes are an intrinsic part of the human condition and operating system, and that the quest for perfection is ultimately misguided, we will do ourselves a great turn. Of all places, art is a spot where mistakes should be considered honored guests.

If we hold ourselves to a standard of always avoiding mistakes, we are essentially setting ourselves up to expect perfection—both in ourselves and in others. Certainly we know that perfection is an unattainable goal. Nevertheless we often maintain that impossible-to-achieve yardstick. In addition to setting ourselves up to feel like perpetual failures, we are overlooking a rich field of potentially fabulous stuff.

In English, we don't have words that bring any nuance to the concept of mistake making the way we do with other words. When we refer to eating meals, we have several ways of giving a lot of information about the meal before ever discussing the actual details of any particular menu. Breakfast, brunch, lunch and dinner are all meals, yet each of those words gives us added information about just what those meals entail. With the word *mistake*, we don't have vocabulary built into the language that gives us options to convey any additional meaning.

It's either a mistake or it's not a mistake. Our language doesn't prepare us to set up our thinking for considering any potential value in mistakes. And so we strive to eliminate mistakes—across the board.

We suffer so much more than we have to when we think of all mistakes as having the same weight.

Paint & Air Chandelier, detail

Paint & Air Archway

I'm going to perform a marriage between two of my favorite topics: one about appreciating mistakes and the other about artists creating gifts for themselves. My proposal is both simple and not so simple. I am suggesting the idea of creating what I'll call an MTZ, a mistake-tolerant zone. Depending upon available resources, this might range from anything such as an extra room, an available garage or shed, or an empty closet, all the way to something as simple as a plain cardboard box. If you're using a cardboard box, then maybe it's something you can keep folded and open up when working, as if creating a barricade around yourself.

Regardless of the particulars of the physical parameters, the idea is to dedicate a space where you can work without any concern about mistake making. In this hamlet, you can proceed carefree from the usual hesitations or cautions that might generally be at your side. This is your world to take, shape and make a mess . . . even a big ol' rotten stinkin' mess.

You might use your MTZ for art making exclusively, or you could find it a valuable setting for plenty of other things: writing, dancing, cooking, singing . . . the list could go on pretty much endlessly. The point is to take this edict to heart and to free yourself of your own automatic judgments and inhibitions. It's hard to think of a better gift.

At some point, you'll take a step back and then can evaluate, trim, edit, rework and refine. The aim is to give yourself the opportunity to branch out before you start "branching in." This is a deliberate opportunity to see your work—and possibly yourself—in a whole new light.

There are serious consequences for not understanding the nature of how **mistakes serve us.**

Flik

We often accept myths as fact. It's not that we've considered the ideas first and then decided to go with the myth. We simply assume there are certain absolutes. However, if we take the time to look deeply, we realize those so-called absolutes may not be so true. Learned skills are separate from creative skills. Sometimes they overlap, but they don't have to. Well-drawn work is not necessarily creative work. And creative expression is not completely dependent on a learned skill. Confusing these two can seriously hold back great reserves of creative gusto.

Remember, and this is important: The ability to achieve figurative representation is just one particular standard of artistic ability.

We are somehow conned into thinking that the world is divided between those who can draw well (a.k.a., the talented) and those who cannot draw well (a.k.a., the untalented). The ability to draw stands like a massive gate at the base of the temple of creative permission. But skill at figurative representation is just that—a particular skill.

The ability to draw well and a creative force are two very different things.

People who have mastered the knack of drawing well aren't any more capable creatively than anyone else. In fact, the process of learning an aesthetic discipline that involves a requisite skill may actually stymie the inherent flow of expression for some. For artists, drawing is a wonderful expertise to acquire, but doggedly adhering to rules of technique can shut us off from roaming into creative territory.

As with so many things in life, achieving a comfortable balance is divine.

Consider the challenge of creating art that doesn't rely on familiar representative forms, but where the artist instead pursues a personal inclination to create something that has not been seen before. **The calling of artists is to lead the way in cultivating new ideas.**

Maybe your idea feels like it's a bit too silly or too lofty, or maybe some "art expert" along the way told you **not to do it!**

Turquoise Beezay

The ability to achieve figurative representation is just one particular standard of artistic ability. We are somehow conned into thinking that the world is divided between those who can draw well (a.k.a., the talented) and those who cannot draw well (a.k.a., the untalented). The ability to draw stands like a massive gate at the base of the temple of creative permission. But skill at figurative representation is just that—a particular skill. **The ability to draw well and a creative force are two very different things.** Sometimes those two things overlap, but not always.

Arapahoe

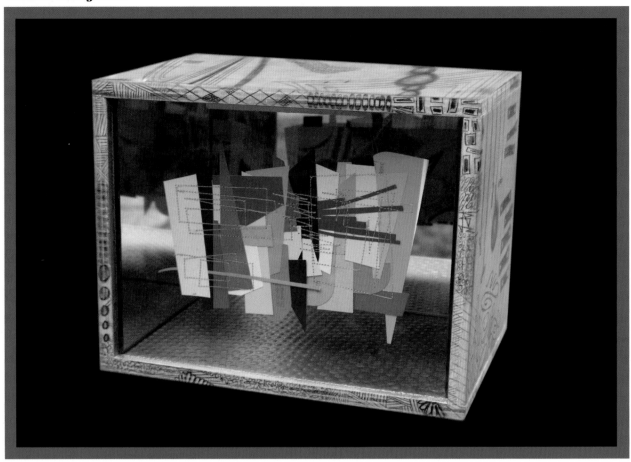

Well, think of this book as your artistic license, your permission to do what just might seem silly or stupid, or might result in an embarrassing flop.

Here's the main point: *Rules for art do not sustain creativity.* In fact, all too often, rules in art have a *crushing effect* on the creative spirit, a delicate essence that can be all too elusive as it is, but which is actually the real driving engine behind art.

In traditional cultures, the visual arts are clearly understood by the community. Motifs used by Native Americans in weaving and pottery were symbols that evoked deep meaning for the members of a particular tribe. People were readily able to enjoy the arts that surrounded them.

In our Western culture, art, which seems to promise a spirit of exuberance and inclusiveness, as well as a commonality in the human experience, can way too often leaves the "uninitiated" shut out, creating a culture of exclusivity. As an artist, I find this to be the very antithesis of the spirit of art.

I am by no means suggesting a dose of banality, but rather a dedication to achieving art of quality as well as accessibility. I am inspired by the rich tradition of American jazz—an art form that is embraced equally by renowned musicologists, as well as by countless "uninitiated" enthusiasts.

When art is at its best, it speaks in a language that doesn't require any particular training. Somehow, because of the specialness of the art itself, it communicates something real, something that can be said only through art.

Becoming an artist is a long, serious progression. It entails much more than learning particular skills or techniques. It's an internal process that ultimately becomes an addiction, a way of life. Artists aren't artists only on certain days at certain times. Artists are artists in the way they think and live in all aspects of life.

Please visit createmixedmedia.com/the-art-of-mistakes for bonus content.

Here's the main point:
Rules for art do not sustain creativity. In fact, all too often, rules in art have a crushing effect on the creative spirit, a delicate essence that can be all too elusive as it is, but which is actually the real driving engine behind art.

Tar Tar Narrow

Crowd Scene

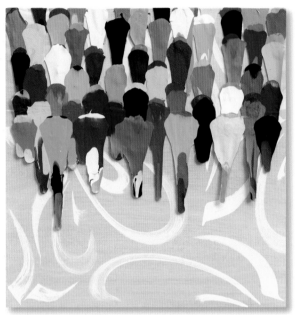

I once met a tailor named Raul, who told me that the very first Friday night he lived in his own apartment after moving out of his parents' house, he went to the store, bought a pie and ate it for dinner. Why? Because he could.

That story has always stuck with me. It's a very short story, but it says a lot.

Living on his own for the first time, he claimed his territory. He announced to himself that there was a new sheriff in town—him.

I see this as a huge lesson for artists.

Creatively, what things would we do differently if we freed ourselves from the rules that bind us?

Step one is figuring out just what rules are in fact binding us or in some way holding us back from roaming into "forbidden territory." This is a formidable task, without a doubt, but spending time considering what work you do to please other people and then considering what work you do to please yourself is a worthwhile exercise.

The joy of being an artist is that the artistic equivalent of eating a whole pie for dinner is not just "okay" to be doing, but actually, it's precisely what artists should be doing—all the time. It's the artist's job to step out, explore and bring back the spoils from that excursion. For me, that's what makes art exciting (or why sometimes art may not feel so exciting). Certainly I don't always like everything I see or do myself, but there's something exhilarating about work that in some way says to the viewer, "I just ate an entire banana cream pie for dinner, and I just might do it again tomorrow."

What a joyful position to be in! **Artists get to have fun and indulge in ways others only dream about but with no horrendous downside. Using the "wrong" color, shape or texture isn't going to land you behind bars or in the emergency room.** Don't worry that you're "wasting" materials. If you test something out that you decide really isn't what you want, those materials aren't wasted. They were instruments used in a lesson to teach you something about refining your creative sensibilities.

The major obstacle in "artistically" eating a whole pie every day might be concern about the judgments of others. "What are people going to think about this?" That's something that can be tough to overcome but very possibly worth the effort.

Ultimately the decision to eat that whole pie or not is up to you . . . whenever you decide who the sheriff in your town is.

54

Please visit createmixedmedia.com/the-art-of-mistakes for bonus content.

Creativity is not just about art. Sometimes it has nothing at all to do with art. Creativity is about how we think, the possibilities we allow into our thinking and our ability to follow through with action. In just about anything we do, we can think creatively or not.

Stripes Bouchee

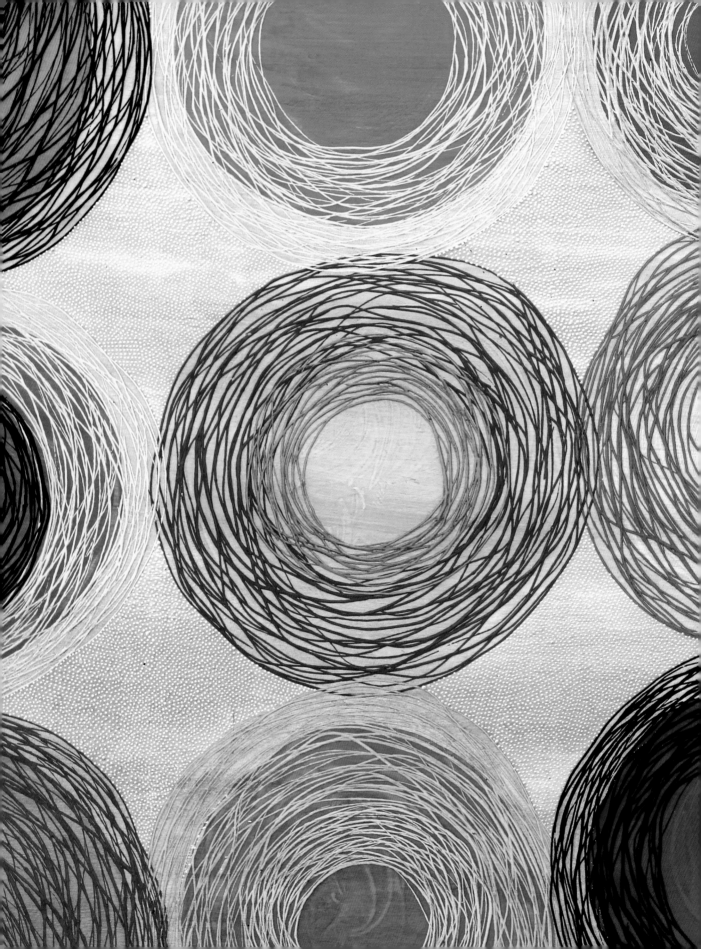

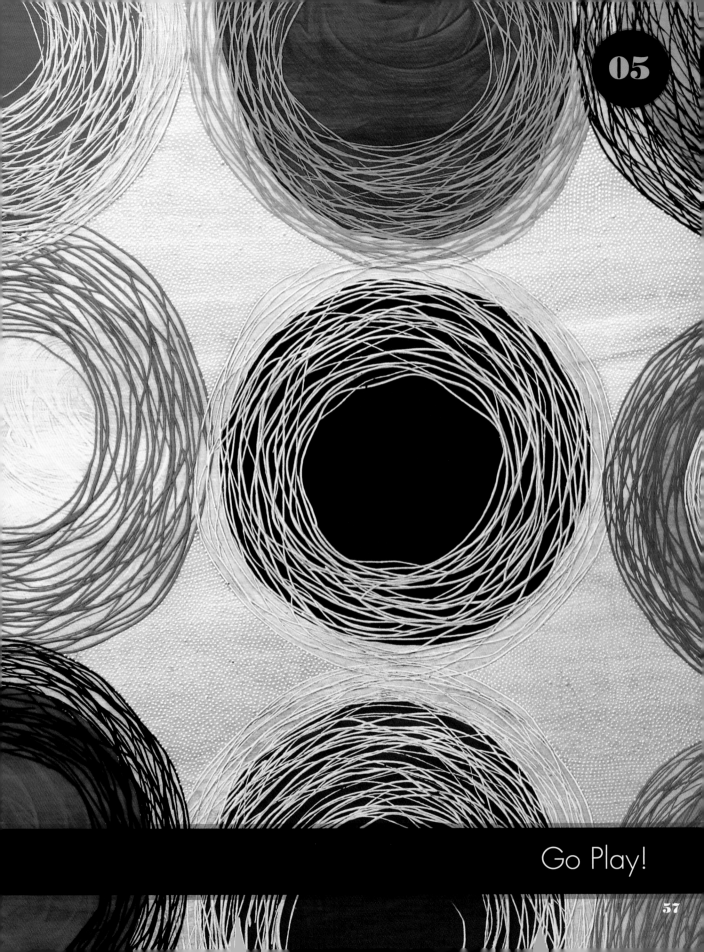

Go Play!

There is no substitute for play. It is creative fuel. Without play, there is no creativity.

Play is serious business for an artist.

Research strongly supports the idea that in order for humans to thrive, play is essential throughout the life cycle.

I believe that artists have a responsibility to keep that concept in good working order.

The best gift an artist can give him or herself is *permission* to follow his or her own aesthetic heart. This is a divine perk that is available to us as bona fide human beings. While other creatures have a basic script of how they must proceed in life (consider worker bees, migratory birds, etc.), we humans get to assemble much of our own lives according to our ability to imagine it.

When you think about being creative—trying new ideas, feeling free, delighting in new discoveries, being wild or pensive—it really doesn't look too different from the way we describe play. Being in a mental play zone is very close to being in creative terrain. We might consider that the only

actual difference is that there's usually some useful product or outcome as a result of being creative, whereas there's not usually a tangible "product" as a result of play. Creativity and play may not be absolutely identical, but they could certainly be thought of as fraternal twins.

Language can be confusing. It's easy to think of play as belonging to the frivolity of childish behavior. In fact, play has a huge role in human development throughout our lives. The actual word *play* often gets a bad rap. But when translated into stuffier language (see sidebar, right), play is considered a precursor to the hugely respected worlds of imagination and—that industry giant—innovation.

Play is what takes us to those new ideas because it allows for exploration and discovery. It's a chance to work things out in a context that "doesn't really matter," so we feel free to roam. Instead of being in a restricted zone where we tend to do familiar, safe things again and again, being in a state of play allows and encourages us to think up and try out new stuff.

Amador

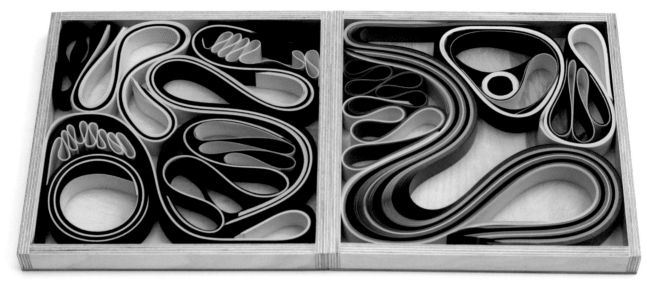

Bent Paper in Trays: Multi-Colored

In some contexts, play can be somewhat dangerous. Even in a sandbox, getting sand in your eyes can be treacherous. But in the context of art, play is a euphorically safe place for discovery. In playing with art, nothing is really off limits; we are "just" playing. We are free from worry and open to possibility. What a destination!

The only thing we have to protect ourselves from are our own feelings of shame or embarrassment that may originate from the judgment of others. What a high price we pay if we allow the potential opinions of others to deprive us of this essential phenomenon, fundamental to developing our artistic souls.

Rather than a particular activity, play, like creativity, refers to a state of mind. We can choose to be playful, or not, in almost everything we do. Preparing a sandwich might be done playfully by coming up with and trying out new ideas (peanut butter with tomatoes?). On the other hand, the very same activity can be accomplished without a hint of playfulness, a repeat of doing something the same way every time. It's more about what's in our heads rather than how our hands are working.

Think Like an 8-Year-Old Boy

Thinking like an eight-year-old boy might be a succinct way of discussing a particular strain of creativity.

I am an only child and was brought up with two girl cousins. When I met my husband, he was already well past adolescence. Then I had a son and was introduced to the whole world of boy-ness. This was an education for me, an entirely new form of life to experience: exuberant, carefree, messy, joyful and maddening . . . sometimes all at once.

An interesting exercise might be to spend an afternoon treating yourself to acting like an eight-year-old boy.

These seem to be the characteristics that define that young male perspective when taking on the world:

- Act without thinking about pretty much anything else
- Don't worry about rules of any sort
- Be as silly as you want
- Don't be afraid to get loud
- Of course, no need whatsoever to be consistent
- Don't be concerned about making a mess; in fact, get messy with gusto
- Feel free to irritate others
- Suit yourself
- Engage in secretive business
- Enjoy living out loud

This ought to set you on a pretty straight path toward playfulness.

Polito

For grown-ups, play requires practice and tenacity. Steadfastness in the belief that playing is worth your time is key. Cultivating a reverence for the value in play is at the core. It's also a skill that entails regular maintenance and upkeep. It requires strength in preserving the deep understanding of the value of play in a world surrounded by disparaging onlookers.

Far be it from me to have written all this and then dish out step-by-step instructions for dedicated repetition. Instead I'm offering some ideas for starting points. None of them need to be followed religiously. They're meant to say, "Take off your shoes and come in, get dirty, find a way that's fun for you to play even if it's not like anyone else's way."

Here you go . . . go play!

Marcel & Bits

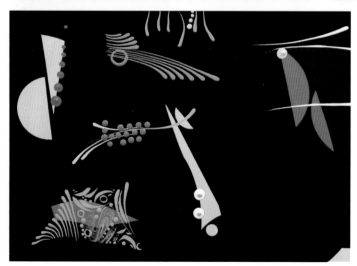

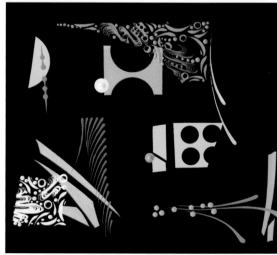

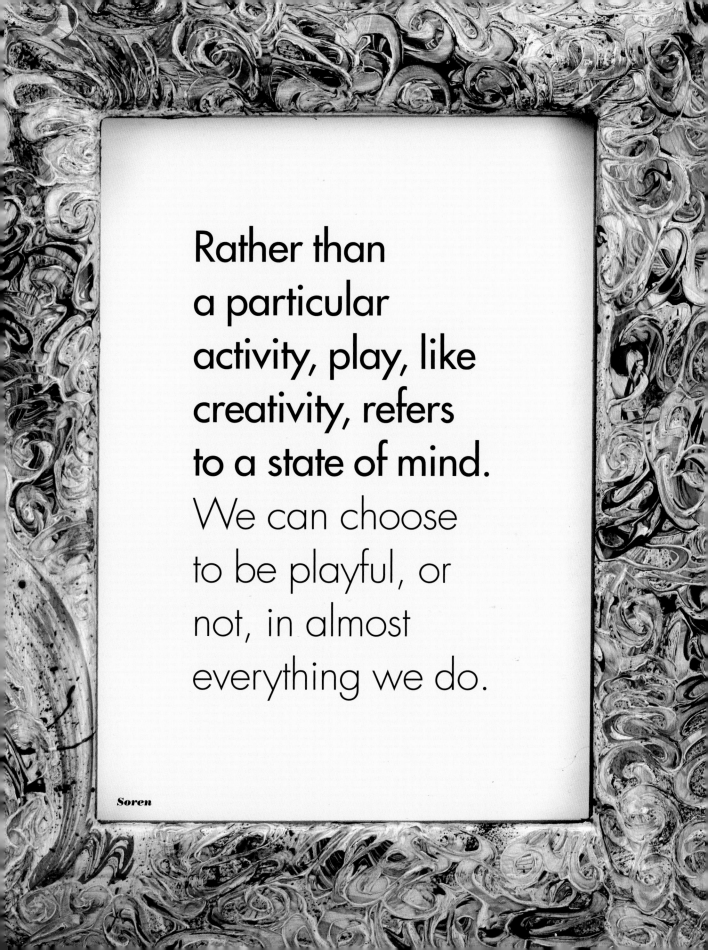

Rather than
a particular
activity, play, like
creativity, refers
to a state of mind.
We can choose
to be playful, or
not, in almost
everything we do.

Soren

BASIC TAPE

Tape is a spectacular material. Endless iterations can be done with tape and paint and more and more layers of tape and paint. In this section, I demonstrate a few basic ideas and ways to get started playing with tape.

After you get comfortable working with tape, you'll probably come up with tons of applications.

While in general I'm a big fan of working with cheap materials whenever possible, I've found that using high-quality tape is well worth the expense. A high-quality masking tape (I like Scotch General Purpose 234) adheres solidly to the surface and does a good job of keeping paint from slipping under the edge of the tape. It also peels off easily and doesn't pull paint off the surface below (of course, you have to be sure your surface is fully dry before putting tape on it in the first place).

materials list

burnisher—wood burnisher (ceramic tool), end of knife, metal bottle opener masking tape, etc.

prepainted wooden board

craft paper or brown paper bag

acrylic paint

paintbrush

3 glasses of water

hair dryer (optional)

TiP

Place a piece of craft paper or other work paper under the board before you start painting. When you need to move the board, you can use the paper instead of touching the wet paint on the board.

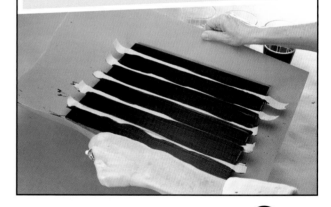

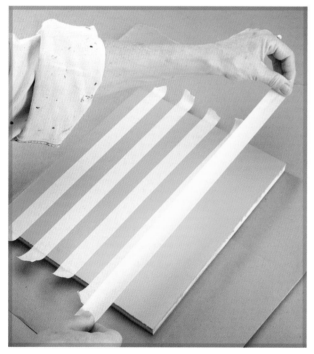

1 Paint a wooden board using an acrylic paint of your choice. Here I've used a latex semigloss house paint. Adhere strips of masking tape on the dry board. Make sure the tape is longer than the board for easy removal later.

TiP

Many stores that sell house paint will sell their mistakes (quarts or gallons of paint in which the final color didn't come out as intended) at a significant discount. It's a good way to buy paint inexpensively so you can work with abandon and not worry about "wasting" costly paint.

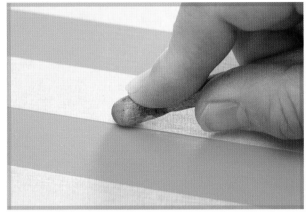

2 Burnish the tape using a metal bottle opener, the dull end of a knife or a wood burnisher.

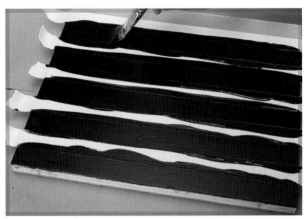

3 Use acrylic paint to paint between the strips of tape.

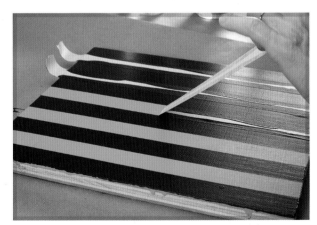

4 Allow the paint to dry naturally, or use a hair dryer to speed up the process. When the paint is completely dry, slowly and cautiously peel the tape off the board.

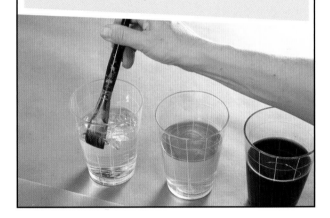

BASIC PAINTING WITH THREAD

Thread is another material that can be a load of fun. I like to use it as a conduit for getting paint onto a surface. Here I demonstrate some basic techniques on sample boards, but the idea of applying paint with thread can be used on all sorts of surfaces.

materials list

painted wooden board

all-purpose thread

acrylic paint

stick of your choice—chopstick, paintbrush handle, etc.

craft paper or paper bag

TiP

Allow yourself plenty of practice using cheap materials so you don't worry about your supplies being too precious while you're getting used to the feel of things.

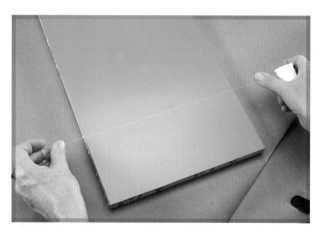

1 Begin with a painted board. Make sure the thread is plenty long enough based on the size of your board and be sure to give yourself extra length for wrapping around your fingers.

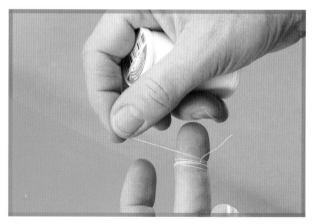

2 Wrap the thread around your finger about three times to anchor it. Then wet it by running it through your mouth. Paint will stick better to thread that is slightly damp rather than bone-dry.

Please visit createmixedmedia.com/the-art-of-mistakes for bonus content.

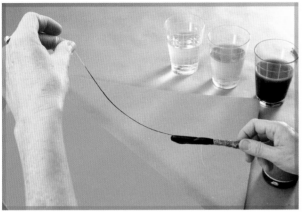

3 Dip a stick (I used half a chopstick) in a cup of acrylic paint. Run the thread through the paint on the stick, pulling the thread along the painted stick. You may need to do this a few times to get the paint fully loaded on the thread.

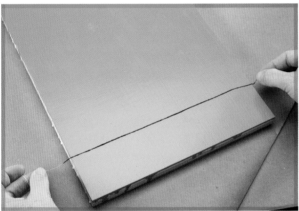
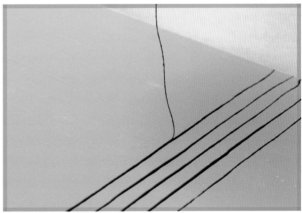

4 Lay the thread on the painted panel (this panel was painted with latex semigloss house paint). Hold the thread with both hands and gently lay it down on the surface. You may feel more comfortable using one hand as an anchor on one end and laying down the rest of the painted thread with your other hand.

5 Peel the thread off the panel immediately, starting with the unanchored hand. The thread is used as a tool to get paint on the surface; the thread itself does not remain on the piece.

After you put the thread down on the surface, you really want to relax your arms and shoulders and let the thread rest on the board. It doesn't need to be laid down taut.

TiP

TAPE AS A SPACER

In addition to using tape as a way to keep paint out of specific areas, tape can also be used as a way to space out a project; i.e., as a sort of shortcut for measuring. When you don't need to work with absolutely exact measurements, using varying widths of tape can save a lot of time and even help you visualize how a project will take shape.

materials list

masking tape

painter's tape

prepainted board

burnisher

acrylic paint

paintbrush

3 glasses of water

thread

craft paper or brown paper bag

TiP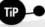

Painter's tape, sometimes blue in color, is essentially less expensive and less sticky masking tape. In this demonstration, it will be used only as a guide for measuring where to lay down the "fancy" masking tape. Save your spacer tape strips; because they don't come into contact with any wet paint, they can be reused many times.

Tape is a forgiving material. Gently use your finger to guide the tape bit by bit to go exactly where you want as you're laying it down.

TiP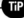

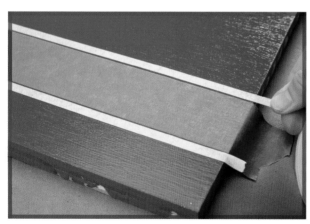

1 Lay a strip of high-quality masking tape on your prepainted board. Add a strip of wide blue painter's tape right next to it. The blue tape will act as a spacer so you can now lay down your next piece of "fancy tape." Lay down the "fancy tape." Remove the blue painter's tape.

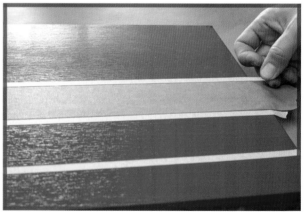

2 Using the same piece of blue painter's tape you just removed, lay it down again on the far side of the "fancy tape" you just put down.

Repeat steps 1 and 2 until you reach the end of the board. You now have evenly spaced stripes without any formal measuring.

68

Please visit createmixedmedia.com/the-art-of-mistakes for bonus content.

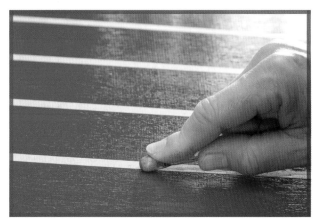

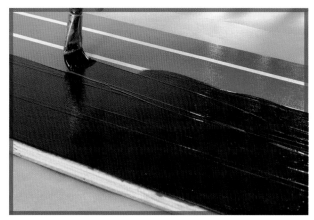

3 After all of your "fancy tape" lines have been laid down, carefully burnish both sides of the tape so paint can't seep under the edges.

4 Paint the board. It's all right to paint right over the tape.

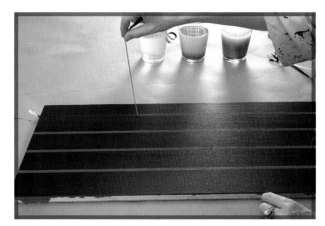

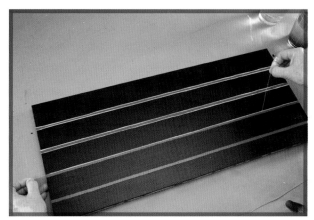

5 Allow the paint to dry completely. Slowly and cautiously peel up the masking tape.

6 If the lines are not as crisp as you'd like, you can disguise frayed edges by laying down thread lines in a contrasting color right along the edges of the painted stripes.

COMBiNiNG LESSONS 1, 2 AND 3

LESSON 04

Each of the lessons demonstrated in these pages is like an ingredient in a soup. Depending on your tastes and tendencies, any of them can be combined with other lessons (or ingredients), cut into pieces or spiced up to create a flavor which suits you. Here I've combined "Basic Tape," and "Basic Painting with Thread" in-between those taped stripes to create new stripes and then "Tape as a Guide" for putting down more lines of paint with thread, this time, putting the thread lines down horizontally to create a plaid or grid effect.

materials list

board from Lesson 1

thread

acrylic paints

stick of your choice—chopstick, paintbrush handle, etc.

cotton swabs

painter's tape

craft paper or brown paper bag

TiP

Experiment with the number, color and spacing of the thread stripes to get different effects and moods.

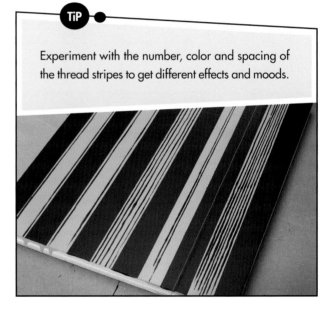

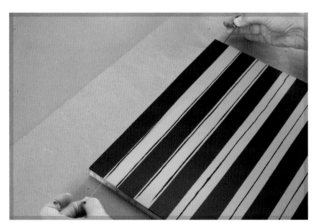

1 Place the board from Lesson 1 on a sheet of craft paper. Use the Basic Painting With Thread technique from Lesson 2 to create thin lines in the yellow space. Create as many lines as you'd like.

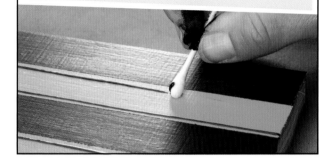

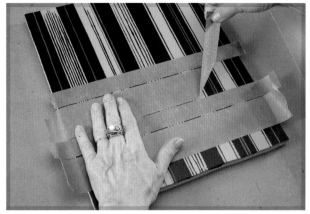

2 Let the paint dry completely. Using the craft paper under your board, turn the board 90° and lay down evenly spaced strips of tape using the method from Lesson 3.

For this step, painter's tape will work for your guideline tape as well as the spacer tape.

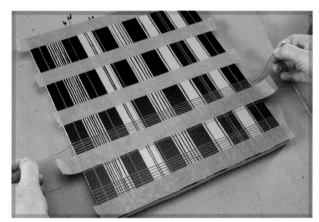

3 Use the tape guidelines as you lay down painted thread to create very thin painted lines that cross over the earlier painted lines.

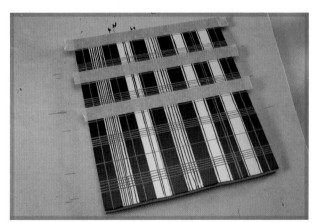

4 Remove the guideline tape to reveal the design.

CUTTiNG SHAPES USiNG TAPE

Part of the beauty of tape is that you can remake it to suit your own desires. You can use any width of tape to create a much wider swath that will open up a host of new possibilities.

materials list

prepainted board

masking tape

self-healing cutting mat

craft knife

fan brush

acrylic paints

needle

thread

empty paint cans (optional)

craft paper or brown paper bag

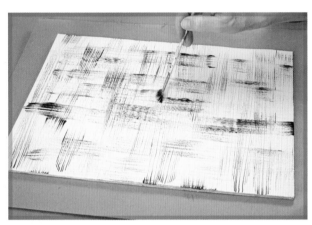

1 Begin with a prepainted board. If you'd like, embellish the board before applying any tape. Here I've used a fan brush to make some light marks on the cream background color.

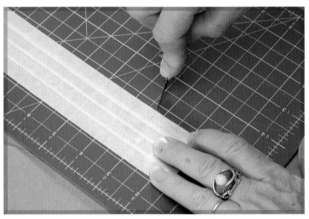

3 Use a craft knife (or razor blade knife) to cut into the wide swath of tape, creating a variety of shapes.

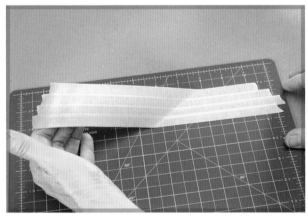

2 While the paint is drying, start to prepare the tape. Slightly overlap strips of high-quality masking tape on a self-healing cutting mat in order to create a very wide piece of tape.

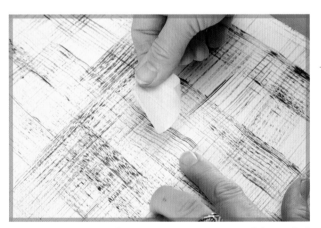

4 Use your tape shapes to cover up areas of the embellished board that you would like to preserve. Look for interesting brushstrokes or other areas that appeal to you. Burnish the tape after you place it.

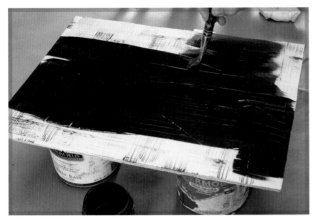

5 After you've placed several pieces of tape on the board, cover the entire piece with acrylic paint.

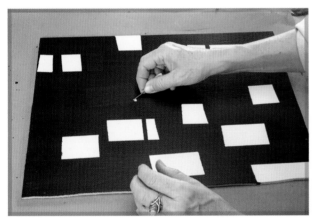

6 After the paint has been allowed to dry, carefully peel up the masking tape. Use the pointy end of a needle to help you peel up the first corner of tape.

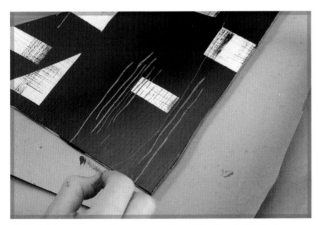

7 Using the technique outlined in Basic Painting With Thread (Lesson 2), add loose paint lines to the preserved areas of the board.

TiP

If you're working on a thinner piece of wood, or would just like to bring the piece closer to eye level, elevate it using empty quart-sized paint cans. This also helps keep paint from getting on your work surface as you paint the edges.

TiP

To help prevent losing the needle and for easier handling, fold a piece of masking tape over the blunt end.

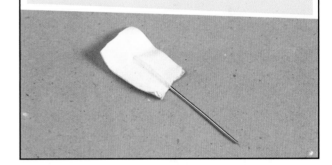

NOTE

I accidentally spattered a little bit of red paint on my board while I was laying down lines. I could remove it with a moistened cotton swab, but I like the way the drips look and how they balance out the board as a whole, so I've decided to leave them.

STAMPiNG WiTH EVERYDAY OBJECTS

Here's a place where you can really cut loose playing. Once you start using nontraditional stamps, you'll start thinking about everything around you with a new twist. Bobby pins, broken car parts, random kitchen utensils . . . so much potential every place you look.

materials list

painted boards

acrylic paints

variety of objects: straws, paintbrushes, rolling pin, etc.

painter's tape

craft paper

Stamping With the Same Color: Rolling Pin

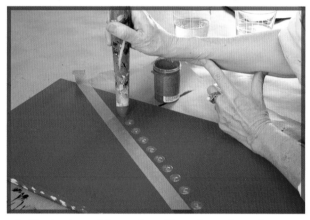

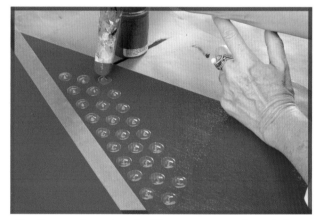

1 Beginning with a painted board, apply a piece of painter's tape along the board as a guide for where to stamp.

Dip the end of a round object (my grandmother's rolling pin in this case) in the paint. The thinner the paint, the more it will "relax," or spread out, creating a larger, flatter shape. The thicker the paint, the more of a raised bump it will produce.

2 Stamp the painted rolling pin on your board along the tape line. Use your opposite arm to steady the arm doing the stamping.

Use the straight line of dots along the tape as a guide for the next line.

TiP

Consider using the same paint color as the paint on the surface of your board to allow just the texture of the dots to be the focal point.

TiP

Hold the stamp on the board for a few seconds to allow the paint to slowly run off the stamp. Re-dip the stamp in paint after each dot to get a uniform size.

Please visit createmixedmedia.com/the-art-of-mistakes for bonus content.

Contrasting Color and Gradation in Size

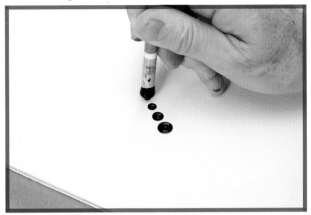

1 Begin with a painted board. Dip an object, in this case the top of an old pastel pencil, in a contrasting color of paint, and stamp it in a line on the board. Do not re-dip the stamp in the paint between the stamp marks. The dots will gradually get smaller.

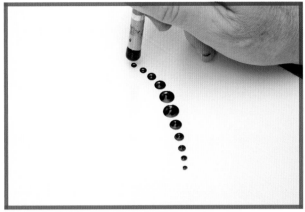

2 After the paint is completely gone from your stamping object, dip it in paint again and continue stamping in another place on the board.

Stamping With a Straw

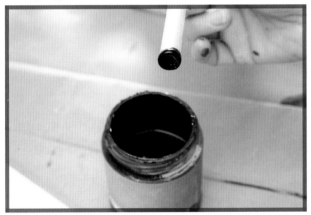

1 Dip a straw in paint. If the opening is completely covered in paint, blow on it to pop the bubble.

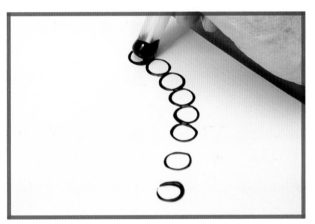

2 Press the straw on the board and roll the straw around to make sure the paint hits all spots. Remove the straw to reveal your mark.

Try combining different types of stamps to create contrasting features.

TiP

iNTEGRATiNG STAMPS WiTH TAPED GROUNDS

Each of these techniques is like a component in the kitchen. Plenty of playtime and experience working with all the ingredients will lead you to your own versions of combining ideas.

materials list

prepainted board

acrylic paint

stamping objects (straw or paintbrush)

craft paper or brown paper bag

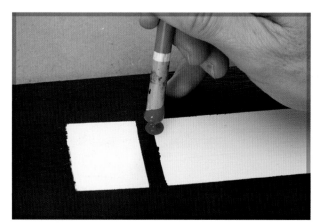

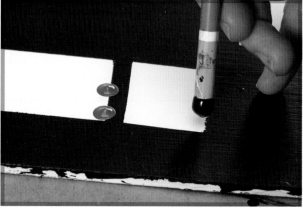

1 Using the board from Lesson 5, remove the tape if you haven't already. Using a small stamping object, dip the stamp in paint and add small dots along the edge of some of the negative space shapes.

2 Continue to add more dots as desired using different colors of paint or different sizes. Whatever your pleasure!

TiP

Although this is a fun technique to use anytime, it is especially helpful for covering unwanted mistakes when some of the top layer of paint crept under the tape into the light background paint.

To get a different perspective, turn the board so you're looking at your piece from a different angle.

TiP

76

Please visit createmixedmedia.com/the-art-of-mistakes for bonus content.

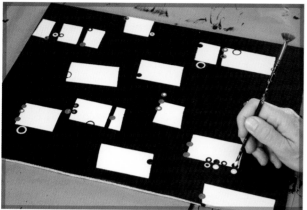

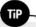 TiP

Only layer selected dots, not all of them.

3 After the stamps have dried thoroughly, use the wrong end of an even smaller paintbrush to layer smaller dot stamps on top of the original dots.

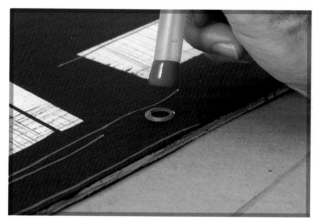

As long as the original dots are really dry, they are very forgiving of mistakes. Use a damp cotton swab to pick up wet paint stamps that you don't like.

TiP

4 You can also add the open circle straw shape.

TiP

Restraint is key to these small shapes. Sometimes fewer carefully placed stamps are more visually appealing than a lot of shapes. It is also important to know that you don't have to place dots in matching locations (two black dots at the top of one square doesn't have to mean two black dots at the top of every other square).

THROWiNG CURLY LiNES

Although it uses the same basic technique of painting with thread as in earlier demos, the approach here is quite different and creates another effect completely. It is much more irreverent—literally throwing caution to the wind.

materials list

prepainted board or scrap paper

mat frame

thread

acrylic paint

stick of your choice—chopstick, paintbrush handle, etc.

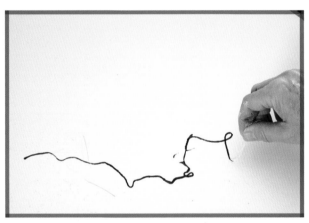

1 Start with a painted wooden board. Cut a length of thread. Run it through your mouth a few times to condition it with your saliva. Dip the handle of a paintbrush or a chopstick into a cup of paint. Run the thread through the mass of paint on the end of the stick. Put the stick back into the cup of paint.

Holding onto one end of the thread, throw the thread up in the air and let it land where it may on the board.

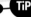
TiP

Relax. Wear old clothes you don't care about when you're doing this. You'll want to feel utterly free and easy to throw that thread and not worry about making a mess. With practice it will feel more comfortable and you'll begin to develop confidence with the technique.

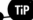
TiP

You might have to run the thread through the paint a few times to get as much paint on it as you'd like.

BONUS ○ ○ ○ ○ ○ ○ ○ ○ ○ ○ ○ ○ ○
Watch a video demonstration of this technique at createmixedmedia.com/the-art-of-mistakes.

78

Please visit createmixedmedia.com/the-art-of-mistakes for bonus content.

2 Gently lift up the thread to remove it. Take care not to pull the thread too quickly because the paint may smear.

3 Reload the brush handle and the thread with paint and continue the throwing process. Turn your board periodically to get thrown lines in various places and in a variety of directions.

4 Instead of throwing from the top and letting the loose end land where it may, you can try a different approach by anchoring one end. Carefully place the painted end of the thread in a particular spot on your board and then gently toss out the remaining length of painted thread to land in a more controlled fashion.

5 This is a great technique for full-out play and fun.

> **TiP**
> If you stop working for any length of time, the thread will dry up and lose its supple quality. Get a new piece of thread whenever the one you've been using starts to dry out.

A SLiGHT SHiFT iN PERSPECTiVE CAN MAKE ALL THE DiFFERENCE

This is a potent exercise in lots of ways. Use a cardboard mat to scan a large swath of curly lines to find small nuggets that have stand-alone appeal. You don't need to justify why those places appeal to you—just follow your instincts, like choosing candies from a big sample box.

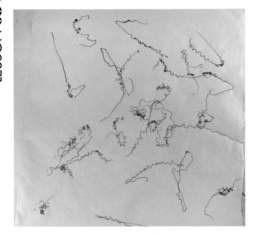

There are lots of ways to work this: First, just move the mat around, keeping an open eye for "moments" that please you. Then step back, walk around the table and try the same thing from another perspective. Try adjusting and turning the paper. Step back and look at it from a distance. Try tossing the mat onto the paper and see if it lands somewhere you hadn't noticed yet. Get a chair or put the paper on the floor so you have a higher view.

The various steps you use here to get a different perspective are useful in a practical sense and they are apt metaphors for looking at any particular situation in many different ways.

Use these little gems to make greeting cards, to frame, to hang as is or come up with your own ideas.

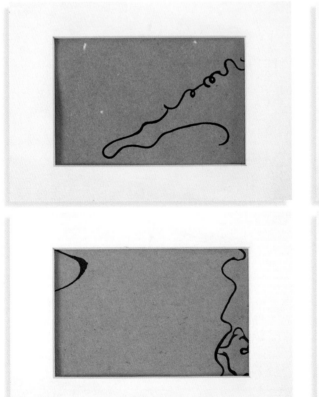

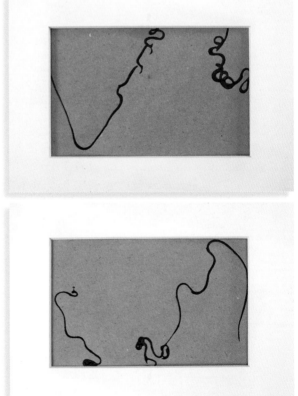

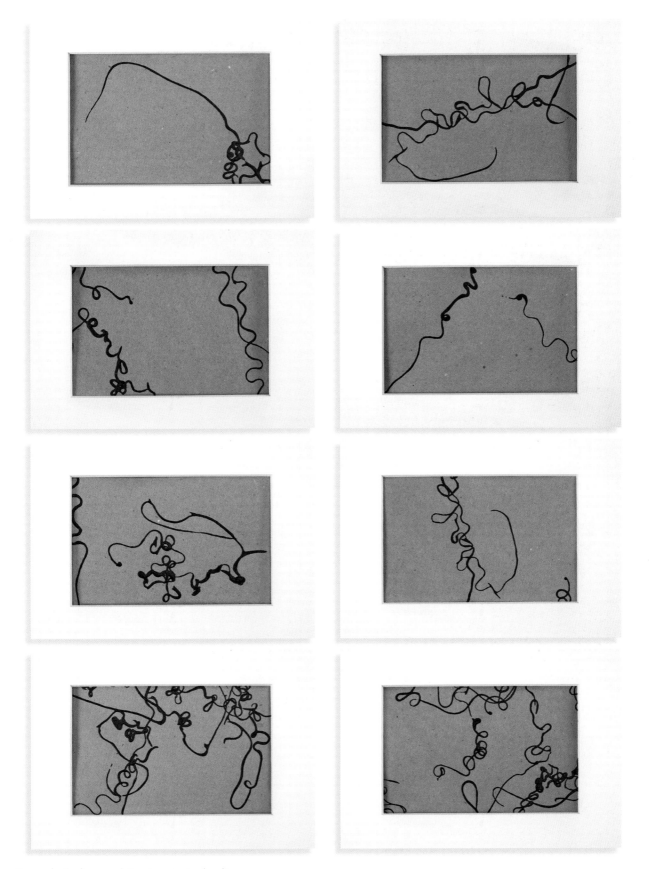

POSSIBILITIES WITH STRIPES

Stripes offer infinite design possibilities. (Personally, I would be thrilled to spend a lifetime devoted to coming up with striped designs.) Tape is a phenomenal tool for creating striped designs.

Here are just a few things to think about with stripes: varying the width, creating stripes with stamped objects, combining straight with relaxed lines, using just two colors, using a variety of shades of just one color, using textures within a stripe.

(If you make a point of looking, you'll see stripes all around you—constantly.)

materials list

prepainted board

masking tape

painter's tape

wax paper

acrylic paint

paintbrush

thread

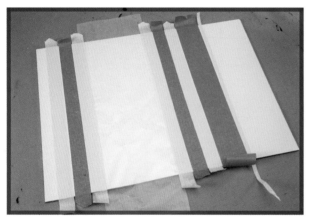

1 Begin with a painted board.

Use wax paper to mask a large area of the board to keep it from coming in contact with paint.

Place rows of tape on the board that will create stripes. The beige masking tape will stay on the board to preserve the base color. The blue guide-line tape serves only as a tool to create distance between the beige tape strips.

> **TIP**
> Use masking tape of different widths to create stripes in a variety of sizes.

> **TIP**
> Using wax paper to cover a portion of the board will prevent wasting large amounts of expensive tape.

Please visit createmixedmedia.com/the-art-of-mistakes for bonus content.

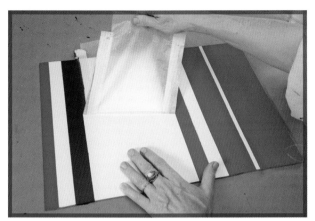

2 Burnish the beige masking tape strips and remove the blue spacer tape.

Paint some of the open spaces (where the blue spacer tape was) in one color and some of the other open spaces in another color. Allow it to dry and paint a second coat.

Allow the second coat to dry and remove the tape to reveal the stripes.

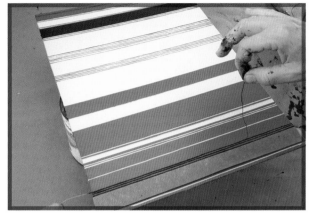

3 Apply one strip of blue guideline tape on the board. Use thread coated in paint to lay down thinner stripes of paint in complementary colors.

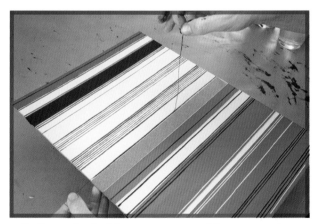

4 Reapply the blue tape as a guideline in another place on the board. Now add more thread lines.

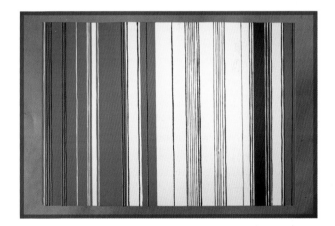

PAiNTiNG WiTH A TOOTHBRUSH AND STRAW

Here the toothbrush is used to apply paint, and blowing through a straw is used to create an added effect. Certainly you may come up with other ways of approaching these simple tools.

materials list

prepainted board

acrylic paint

used toothbrush

straw

glass of water

cotton swabs

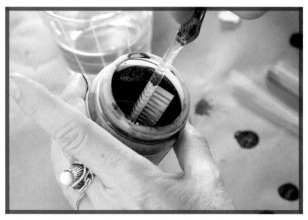

1 Wet the toothbrush with water and dip it in the paint. The paint should be watered down slightly; add water in the smallest increments possible.

TiP

Use your fingers to drip small amounts of water into your paint. This will prevent you from adding too much water at one time. You can always add more water. It's easier to keep thinning than it is to try to thicken it back up. (However, if you do wind up thinning your paint more than you'd planned, see if you can play and find some way to work with the superthin mixture.)

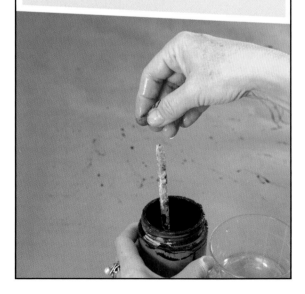

TiP

Wear work clothes you don't care about. You'll want to feel free to make a mess.

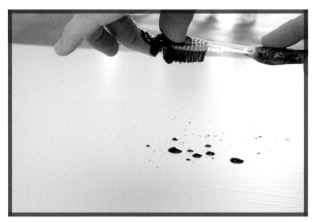

2 Flick the bristles of the brush to splatter the paint on the board.

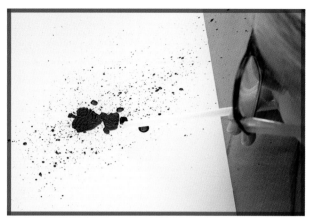

3 Before the paint is dry, blow through a straw to spread the paint out.

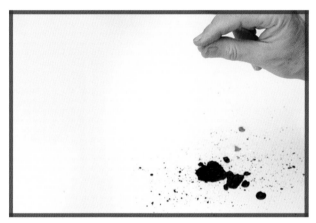

4 If the paint is too thick to move with the straw, drip a few drops of water onto the paint and blow it with a straw again.

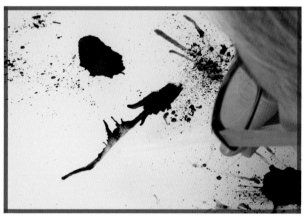

5 Turn the board as you blow the paint to get it to move in different directions.

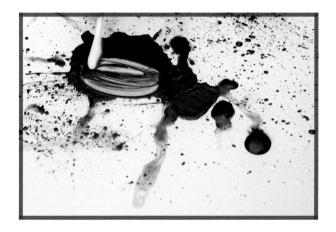

6 If you want to remove some of the paint, wet a cotton swab with some spit and rub the paint away.

DOTTED DiMENSiONAL FABRiC PAiNT

Although I'm using dimensional fabric paint, I'm not using it on fabric. Fabric paint has a wonderful, meaty thickness for working on a hard, smooth surface.

materials list

prepainted board

painter's tape

needle with masking tape handle

dimensional fabric paint

TiP

You can use other paints with this technique, but fabric paint has a great consistency that doesn't run.

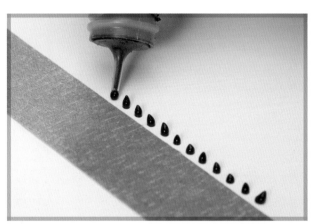

1 Place a piece of guideline tape along a painted board. Add a row of dots using dimensional fabric paint.

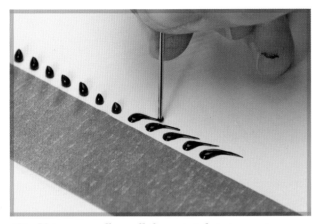

2 Using a needle, pull the paint dots to create a flourish.

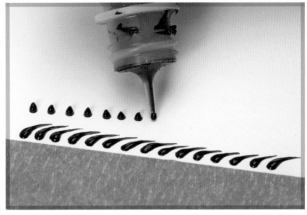

3 Add another row of dots along the first row.

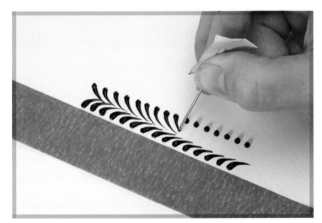

4 Continue pulling flourishes in the opposite direction.

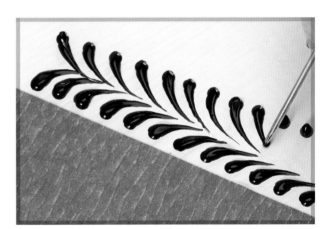

TAPiNG FREE-FORM CURVED SHAPES

In the world of materials, tape is easy to get along with. It's pliable, so you can guide it with your fingers to create subtle curves.

materials list

prepainted board

acrylic paint

masking tape

paintbrush

burnisher

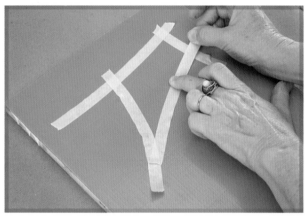

1 Begin with a painted board.
Place strips of high-quality masking tape on the board. Take advantage of the tape's elasticity by pulling it into a slight curve. Create an enclosed shape. Burnish the tape well.

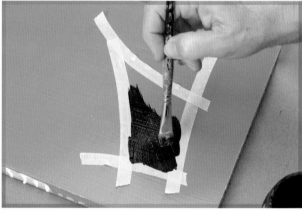

2 Paint inside the shape using a contrasting color.

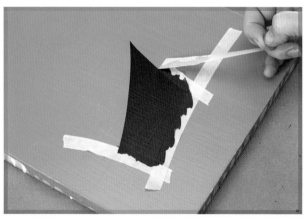

3 Allow the paint to dry and remove the tape to reveal a subtly curved shape.

88

Please visit createmixedmedia.com/the-art-of-mistakes for bonus content.

OTHER PAiNTiNG TECHNiQUES

LESSON 13

The possibilities are endless. Here are just a few ideas to get you started.

Feathering

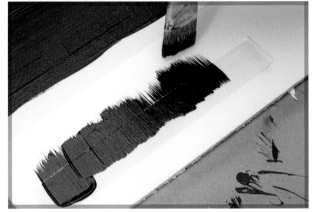

1 Place a piece of tape on a painted board. Load a brush with paint and sweep the brush, allowing it to naturally raise from the board at the end of the stroke. This will create a feathered effect.

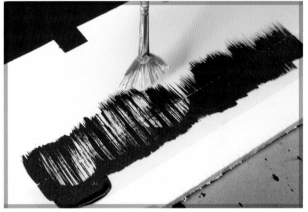

2 After the feathered paint has dried, use a fan brush loaded with paint that matches the background to add more depth to the feathering. Allow the paint to dry and remove the tape.

Blocking

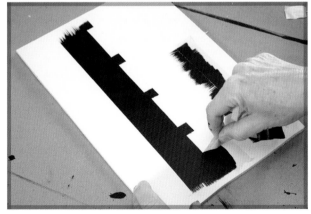

1 Place rectangular pieces of masking tape on a prepainted board. Burnish the tape, then paint over the pieces with acrylic paint. Allow the paint to dry and then remove the tape. Experiment with the size and spacing of the tape.

Flourishes

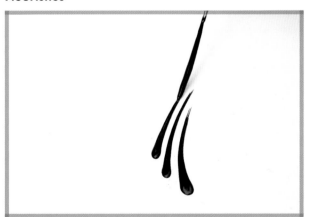

1 Load a liner brush fairly thickly with paint. Place the tip on the board and pull it out. This will create a flourish that is thick with paint at the beginning and thinner toward the end.

USING FINGERS AS TOOLS

Fingers are always available, come in a variety of sizes, can create lines as well as texture and clean up easily.

materials list

prepainted board

acrylic paint

paintbrush

paper towels

masking tape

craft paper

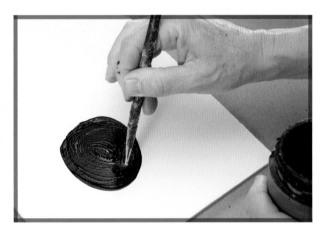

1 Paint a circle.

I've had great results with Viva paper towels. I find them to be cloth-like and durable. I am able to use them for quite a while before tossing.

 TiP

Please visit createmixedmedia.com/the-art-of-mistakes for bonus content.

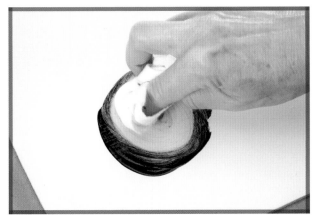

2 Wet a paper towel with saliva and rub the paint to remove some of it

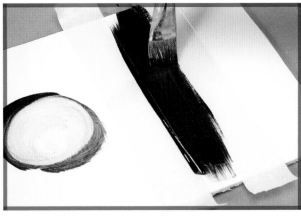

3 Add two strips of tape and paint between them.

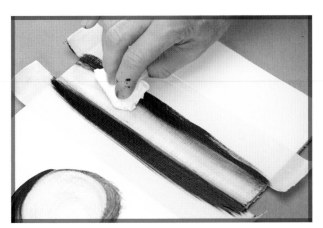

4 Wet a paper towel with saliva and rub the paint between the two strips to remove some of it. If one paper towel becomes too covered in paint, grab a new one and continue.

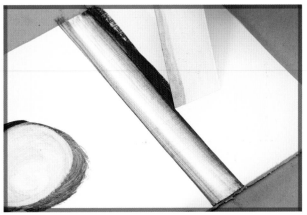

5 Allow the paint to dry and remove the tape carefully.

ROCCO SHAPES

I was inspired by my neighborhood Italian restaurant to call this design "Rocco" because of all the round letters which follow the letter *R*.

materials list

prepainted board

chalk pencil

acrylic paints

paintbrush

paper towels

thread

3 glasses of water

craft paper

1 Start with a painted board.
Use a chalk pencil to create some light, casual guidelines.

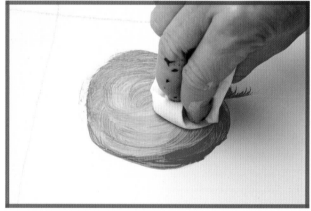

2 Paint a round shape in one of the areas using a brush.
Moisten a paper towel using your saliva and rub away some of the paint.
Repeat in each section of the board.

Please visit createmixedmedia.com/the-art-of-mistakes for bonus content.

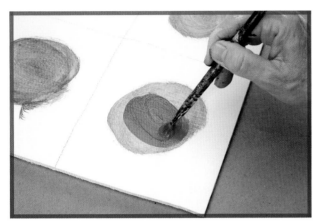

3 Add another layer of paint to the circles.

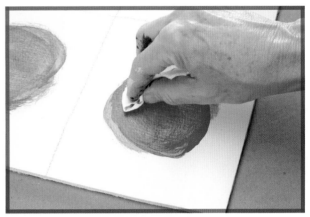

4 Wipe off the new paint using the same technique. This building up of layers creates an appealing effect.

5 Cut a short length of thread and run it through your mouth to moisten it.

Cover the thread with paint using the technique shown in Lesson 2. Hold it at both ends instead of wrapping one end around your finger.

Place the drooped middle carefully at the bottom of one circle.

Slowly and deliberately wrap one end of the thread around the painted circle and then pull it up, leaving the center of the thread on the board. Drop the other end of thread around the other side of the circle and pull up.

6 Repeat step 5 multiple times. Repeat on all
the circles and feel free to change paint
colors as desired.

Use a shorter thread to add more deliber-
ate lines in the open areas (shorter thread is
easier to control).

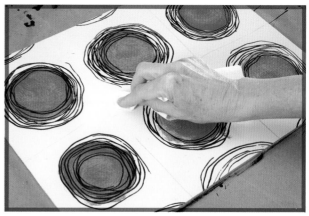

7 Add curved lines that go off the edges of the
board to show that the design continues even
though the board doesn't.

After the circles have dried, use a damp paper
towel to wipe away the gridlines.

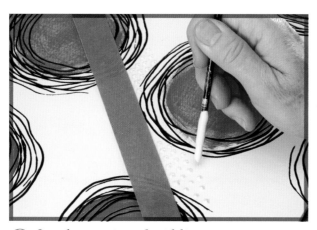

8 Lay down a piece of guideline tape.
Use the end of a small paintbrush to stamp dots
along the guideline until you've created a full row.
Use that row as a guideline to create the next row.
Repeat until the board is covered in dots or until
you have as many dots as you want.

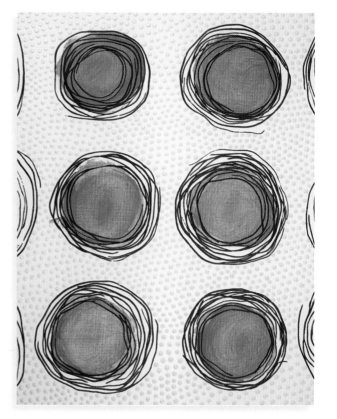

94

Please visit createmixedmedia.com/the-art-of-mistakes for bonus content.

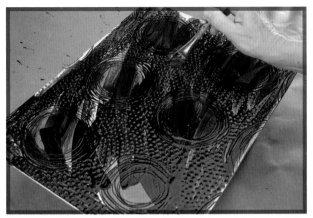

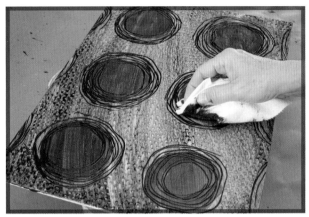

9 After all the dots are dry, you might choose to put a watercolor wash over the whole thing. Using very thin paint, brush a layer over the whole piece.

10 Before the paint is dry, use damp paper towels to wipe away the excess paint.

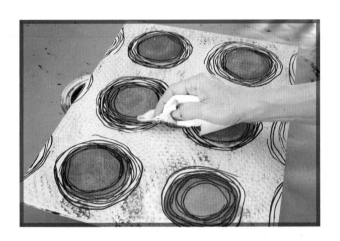

11 As you wipe away, continue to use new paper towels dipped in water so all you are left with is a hint of the paint.

COMBiNiNG LESSONS

Here I've played with combining a few different techniques. As you do the same, keep in mind that more isn't always better. Sometimes you may find just a couple of methods you quite like and decide to work with a small number of approaches.

materials list

prepainted board

acrylic paints

paintbrush

craft paper

paper towels

masking tape

liner brush

TiP

You don't always have to use a brand-new, perfect brush. Sometimes using an old brush can give an unexpected yet pleasing effect.

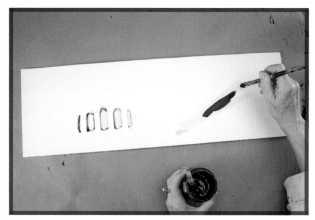

1 Begin with a painted board.
Tape off two sides of a free-form shape.
Use a small paintbrush to sweep paint inside the shape.

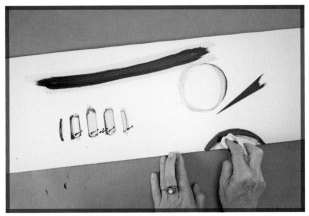

2 In selected areas, paint shapes and then wipe away most of the paint using a damp paper towel.

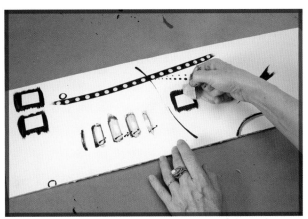

3 Stamp dots of paint in selected areas of the board. Mask an area or two with masking tape, burnish and paint over the tape. Peel it up with a needle to reveal the design.

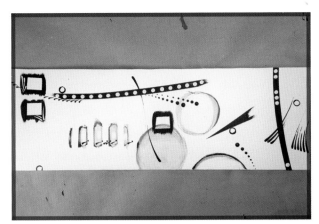

4 Continue adding any of the previous design elements, or others that you discover, to the board.

TiP

Sometimes you need to take a break and come back to a piece in order to get a fresh perspective. This piece is a work in progress. I'll come back to it over the course of a few weeks or months until I think it's complete.

DEVELOP AN iNSPiRATiON BANK

I always felt kind of guilty about all the tidbits I couldn't resist bringing into my life. And then I found out that Andy Warhol had multiple warehouses full of "stuff." At an exhibit of the work of Ray and Charles Eames at the Los Angeles County Museum of Art, huge chests of open drawers with Plexiglas lids held endless amounts of little things.

Could it be? My innate urge to gather, arrange, store and ogle had a venerated tradition among artistic heavyweights.

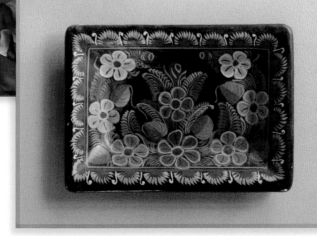

The best thing about accessioning these little delights along the way is not having to feel they need be justified. Sometimes, just the right little box, a scissor with handles that are rusted "in a particular way" or a leftover drive shaft from your mechanic's shop delivers just the bit of inspiration that propels you to take a next step.

Start clipping, tearing and saving whatever catches your fancy. You absolutely don't have to defend why you love a particular shred of something, not even to yourself. Just feeling a connection to a particular swatch or shard is enough to justify claiming it as special to you.

When you have a nice bundle of specimens, think about a way to weave them into your visual world. You might let these little wonders find their way into a variety of crevices that surround you. Or you might try creating a makeshift "creativity altar" of sorts, using bulletin boards, shoe boxes, a chest of drawers or a series of shelves.

Spending time focusing on the concentration of things that excite you is a nice lubricant for creative play.

USE CHEAP MATERiALS

Sometimes it's good to be cheap. Inexpensive materials allow you to stray. If you've invested a lot of money in supplies, you may be prone to feeling that it's all terribly precious, leaving you unnecessarily reluctant to just dig in. Feeling timid in the face of expensive materials can really hold you back from getting your feet wet. Instead try to warm up with some scrappy bits you either have lying around or can get ahold of without spending too much.

There will certainly be times you'll want to splurge on pricier things, but that's not necessarily the best way to get started. Pricey stuff can prevent you from doing the wandering and roaming that will let you carve your own ways.

Flea markets, thrift stores and garage sales are meccas for gathering supplies for creative work.

A few inexpensive ideas:

- Paint on the inside (unprinted side) of paper bags or pieces of cardboard boxes.
- Check out materials you may not realize you have on hand, like water-based house paint.
- Cook a beet and use that water to paint with; it makes a beautiful color.

Warm up with some casual projects like making a birthday card or a welcome home sign to hang on your neighbor's door.

For something a little more permanent, look for a local cabinetmaker or lumberyard and ask about scraps. Frame shops can be a good source for leftover mat board. Many shops are happy to get rid of what they consider trash, or perhaps they'll sell scrap extremely reasonably. You might even talk with them about cutting it into specific sizes for you.

The point is to go with whatever meager materials you manage to find and then just cut loose. If materials are cheap and readily available, there's really not much to lose. If they're not perfect in some respect, great. Try to take your misshapen materials as a creative challenge and find some way you can work with them. You may just stumble onto a very inspiring method. **Always remember: Artists make the most of available resources.**

Focus on the skill of creating adaptable alternatives to your original plans. That's an important muscle to begin to trust and develop.

When you're warmed up a little, you may want to add a few purchased materials that really catch your fancy—maybe some particular paint colors or a brush or two that especially intrigue you, perhaps even a type of paper with a texture that just drives you wild.

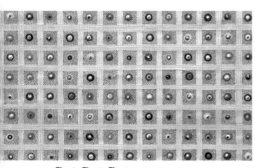

Dot, Dot, Dot

Dolce

M.R. Color Chart

Colored Dots on Black

Please visit createmixedmedia.com/the-art-of-mistakes for bonus content.

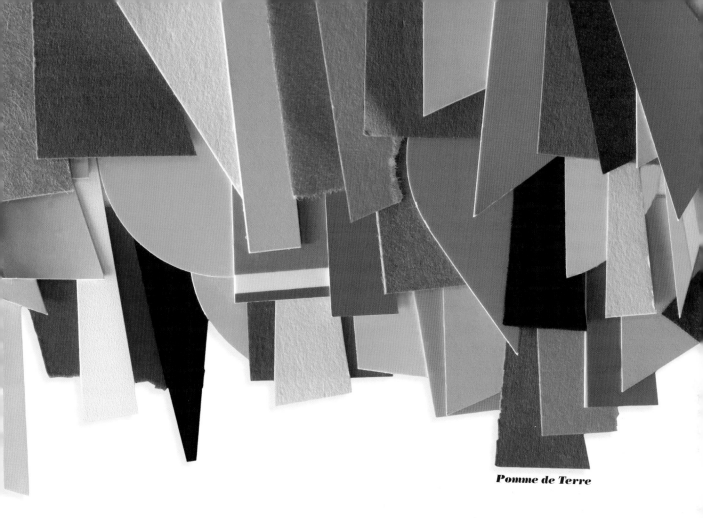

Pomme de Terre

CREATE YOUR OWN COLOR WAREHOUSE

Colors aren't just something to fill in with at the end of a project. Color can be the thing that gets you going from the start. A collection of colors is a springboard for inspiration. The bigger the gathering of colors, the more you can play around with new pairings and combinations.

Create a system for collecting and storing colors that excite you.

Color samples really are everywhere:
- paint chips
- magazine clippings
- food packaging
- fabric scraps

The particular format for your color warehouse doesn't really matter. You could use a journal, a shoe box, a bulletin board, a drawer, etc. It's all about devising a system for hanging onto inspirations in the form of colors.

Design an Exhibit Just for Yourself . . . Imagine Your Dream Show

Consider designing a show of your work that only you would see. That's right. Nobody else would be allowed into this show, only you. You would be doing work strictly for yourself. What would that look like?

Later on, if you wanted to and only if, you could consider inviting one or two other people in to see it as well. That would be up to you. You might also want to consider if there are any people you would absolutely not want to have attend. That might be good information, too.

This could be a special gift you give yourself. It might be something you want to plan for yourself for a birthday or other milestone down the road.

Or, imagine you've just walked into a dream show.

Suppose you were walking in an area you found somehow exciting. Maybe it was in a dream, and you came across a gallery that looked full of wonders from a distance. What might you fantasize would be inside such a promised land? Picture what this work, which just sent you soaring, looked like. Play with really getting into how it would all look, feel, etc. Think about creating that exhibit or part of it in some way. Even if you can't do the full-out ideal, try creating even just one tiny thing that could be part of that show.

Iredale

ARTISTS + FRAMES + TRASH

REFRAMING

I spent a lot of years creating picture frames—frames in all different sizes, widths and certainly designs. Eventually I came to realize that the task of an artist is really all about reframing.

What we frame and how we frame things—on our walls and in our heads—more or less reflects the way we think about the world around us. The things we revere go inside the frames. We look at those things over and over again, and have ongoing reminders about what we admire.

But it also eliminates from our view and our thinking what we've discarded, both literally and in a larger all-around way of thinking. Of course, we always need to evaluate and make decisions about what we like and want, and what we choose to eliminate from our lives.

But there's great danger in automatically accepting predigested and boilerplate decrees.

I believe there's a lot to be learned from the trash. The whole field of archeology is based on trash—albeit very old trash. Thinking about trash is very relevant for artists.

Things we eliminate go out with the trash. The trash becomes a category we disregard altogether: dismissed, done and finished. And we become conditioned to avert our glance from the trash left along the side of the road. We reject the category, categorically.

But what if we take another look? What if we ask ourselves if there's anything in the trash that could possibly be of value to us?

Each of us sees the world around us in different ways. What makes artists artists is that they have the ability to see things that others don't notice as readily. They bring those observations to their art making.

Andy Warhol saw art when he looked at that can of soup, while millions of others (including the maker) just saw soup. In that instance, he opened the world's eyes to the idea of seeing things differently.

If you want to see things differently, you might start by approaching things differently.

Developing the ability to see trash in new ways will go a long way in enhancing your creative muscle.

Some of us are used to going to thrift shops, the halfway homes for trash. The lucky pieces get rescued. But what about giving all trash at least the same deference as what we find in thrift shops? Talk about reframing!

This is an interesting exercise you can easily practice while walking, riding or just being.

See if you can look at various collections of trash (the under-the-sink kind as well as the side-of-the-road type) and somehow see something that you heretofore wouldn't have considered.

Think about the maybes:
- Maybe there's an accidental pairing of colors that could be exciting if used in another context.
- Maybe the top of the broken table lying on the curb could be used as a garden gate.
- Maybe seeing the corncobs covered in coffee grounds made you think of adding a sprinkling of black to a project you're doing.
- Maybe . . .

PROJECT:

Do a surface design on something that can be used as a trash can.

1. It will serve as an ongoing metaphorical reminder.
2. Working on a trash can should be a fairly freeing exercise (just the concept of a trash can practically force a devil-may-care attitude).

Each of us sees the world around us in different ways. What makes artists artists is that they have the ability to see things that others don't notice as readily. They bring those observations to their art making.

Bolero

Box for Kitchen Notes

I often get a lot of pleasure from making art to give away, whether it's a greeting card or something much more ample. It's a chance to break away and meander into new territory. At some point, it occurred to me that I should lavish some time on a gift **for** me, **from** me.

The criterion is pretty simple: something that I feel inclined to make and do not need to justify one whit. Maybe it's impractical or weird or doesn't seem like the type of thing I usually do, but that's all right. That's part of the gift of the gift.

For the last three years, I've given myself a gift that I've made. The first was a 37"-long (94cm) tea caddy. I just had a yen. Forget about the fact that it wasn't until after I'd finished it that I realized I had absolutely no idea where to keep it. But I loved it. Eventually I found a place for it to live discreetly under my coffee table, where it's actually very handy for serving.

The next year I made a box with compartments for all my food-related bits of information: recipes, cards from restaurants, fortunes from fortune cookies, notes from favorite dishes, etc. I spent a huge amount of time painting the box with layer after layer of paint. Although I was excited about it, I at first thought it would be an anomaly in terms of the general direction of my work. But after a short time, I found that my enthusiasm for it has driven my work into a different route.

I find that giving myself a gift once a year is a nice frequency; it's occasional enough that the time and resources lavished on it feel special rather than overly indulgent. Yet, it's regular enough that it's always fun to think about what the next plan will be.

Tea Caddy

The Lifelong Advantage of Creativity

Plaid, browns

Creativity is not just about art. Often it has nothing at all to do with art. Creativity is about how we think, the possibilities we allow into our thinking and our ability to follow through with action. In just about anything we do, we can think creatively or not.

Sometimes art is creative, but not always. In the end, art may not even be the real goal—the muscle for creative thinking is the ultimate sweet spot. Art, done consciously and mindfully, can be a dynamic conduit for nurturing creative thinking.

Everything the human race has achieved—or overlooked—is the result of the ability to think creatively, or not.

In general, I believe there is a large-scale problem with how creativity is often thought about and understood.

There seems to exist a moat of sorts around the whole concept, an unspoken but pervasive and insidious message coming from someplace nobody exactly knows but most everyone seems to respect, that says, "This calls for a higher state of consciousness than you'll ever be able to muster."

I have a much different perspective.

I believe that we are brought to our most potent expression of being human when we exercise our creative abilities, which we all have in various respects. Certain things in nature happen automatically: Caterpillars turn into butterflies. They don't have to think about it; it just happens. Tadpoles turn into frogs; once again, it all happens without the tadpole specifically advocating for a shot at the next stage. After those miraculous changes, the frog doesn't really get to do much in the way of making life choices. Generation after generation of beavers build their dams in the same way over hundreds of thousands of years. The new generations of beavers don't try innovative alternatives. The script is essentially set in stone.

And while physical human development pretty much happens automatically as well, humans are capable of an entirely unique level of development. I would say that level could be considered creativity. It's the part of us that isn't automatic but that we in large part determine; it's the unscripted portions of our lives.

To be the fullest humans we can, we must have the courage to do things that express who we really are—our beings. I'm not talking about making choices from a set of options that have been laid out for us. I'm referring to finding a distinct way of somehow conveying something about our individual self, our aspirations.

Too many people feel they are locked out of artistic circles (from making or even enjoying art) because they lack the adequate education or sophistication "to belong." Certainly a significant swath enjoys major benefits in terms of status and financial gain from maintaining this culture of exclusivity. This is completely antithetical to the underlying spirit of creativity and of art—what might be considered the essence of our humanness.

In the most fundamental sense, the role of the creative person or artist is to question the status quo with creative output. This might be the work of a visual artist, a musician, an actor, a writer; or it could just as easily be a chef who finds a new way to make grilled cheese or a surgeon who develops a new approach to a procedure. It could also be your boss at work who's willing to try out a new plan of action, or it could be a community organizer who refuses to yield to the conforming powers that be (and winds up president of a major world power).

Genuine creativity, the kind that moves our species forward, depends on an all-inclusive structure; it cannot function the way it's supposed to when it serves just the upper crust. If art and music were limited to Ivy League input, teenagers would still be doing the minuet, Beatles would just be bugs and Campbell's soup cans would just be, well, soup cans.

Creative thinkers, whether they be artists or not, are willing to fight conformity and are willing to take on the continuing need to reevaluate what defines conformity. They don't need a degree in anything from anywhere to do that; they just have to believe in their gut that it's what they must do.

Please visit createmixedmedia.com/the-art-of-mistakes for bonus content.

Creative thinkers, whether they be **artists or not, are willing to fight conformity and are willing to take on the continuing need to reevaluate what defines conformity.** They don't need a degree in anything from anywhere to do that; they just have to believe in their gut that it's what they must do.

Jonnycakes

SOME HiSTORY ABOUT THE NOTiON OF CREATiViTY

Drips on Stripes

The whole notion of creativity seems to have confounded people . . . essentially forever.

It's no surprise that ideas about creativity seem to reflect the greater societal influences of their time.

In ancient times, life centered around existence of the gods. The concept of creativity existed essentially in the exclusive realm of the divine. Perhaps a muse or two would be sent to act as a conduit for bringing some of the ethereal magic to a few chosen mortals from time to time. But creativity was among the great mysteries or madnesses of life.

Around the middle of the twentieth century, specific thinking about creativity was percolating in a few different pockets. Creativity became a focus of interest for business leaders as well the psychological community.

In 1950, the president of the American Psychological Association, J. P. Guilford, became interested in the concept of creativity as a bona fide social science and urged his colleagues to study it formally.

A pretty brilliant guy from the world of advertising, Alex Osborn, had an inspired idea to come up with systems or steps for harnessing creativity. It was a new way of thinking about applying our imaginations.

Studies that observed highly creative people were done in order to determine the characteristics that were typical of creative folks. After years of research, various traits emerged that seemed to be displayed over and over again by people identified as being creative. While not all traits apply to all creatively inclined people, the list includes:

- playful
- observant
- tolerant of ambiguity
- sensitive
- perceptive
- having a sense of humor
- complex
- persistent
- not motivated by money
- able to move from one extreme to the other
- smart yet naïve
- adaptable

Eventually a framework was outlined about how the stages of creativity unfold. The bare-bones premise that emerged begins with generating a boatload of ideas with no holds barred. This can only be genuinely accomplished in an

Please visit createmixedmedia.com/the-art-of-mistakes for bonus content.

atmosphere where people feel "intrinsic motivation" (what I call being turned on) and are unconcerned about negative judgments (what other people think). Then, from these myriad possibilities, a few thoughts develop as front-runners. These prized ideas are then well worth the energy it takes to further refine, develope and utilize.

The world of creative problem solving (CPS) devised formal systems for harnessing and employing this creative arc. It is based on the premise that being aware of and following the stages in the creative process can reshape the way people think. The fundamental beliefs are that everyone is creative in some respect and that creative ability can be developed.

The social sciences continue to look at all sorts of conditions that promote or discourage a creative climate.

In general, the whole process struck me as quite similar to the way evolution works: generating and gathering a ton of ideas with abandon, testing things out, seeing what works, dropping what doesn't and finally coming up with something new (like maybe an opposable thumb). Then new ideas form on top of previous ideas, and it all just goes on and on and on.

In evolution, nature creates multiple variations, only some of which move forward. The creative process mimics evolution in that respect: You have to play with lots of possibilities in order to come up with meaningful stuff. Great ideas don't just emerge independently in one fell swoop. Every new door opens another new door. Think of all the things that can be done with an opposable thumb that couldn't have been done before that innovation came into being. One idea can spawn endless more ideas. New ideas are starting places for so many more new ideas: the wheel, concrete, anesthesia, airplanes, computers . . . Each of those ideas unleashes a new starting point for infinite more possibilities.

In nature, evolution happens over long stretches of time. The details of those changes are the focus of tremendous study and scrutiny. Human beings are social creatures and are affected by the traditions, rules and thoughts of society. Our ideas can be hampered by the mores or traditions of the culture around us.

In general, fostering a climate in which people feel free to explore ideas without worrying about making mistakes—basically, without the fear of being judged or ridiculed by others—is at the foundation of what scientists believe fosters creative thinking. With that framework in place, a host of techniques or processes have been developed by a wide range of "creativity practitioners" for inspiring creative thinking. While these trainings are often utilized by industry as it seeks ways to constantly be innovative, a great deal of the underlying premise from these structures is deeply relevant to all of us as creative beings.

We are all darn lucky not to be spiders or banana slugs. They have no alternatives. Stick to the script, kid. That's it. Under those circumstances, it would be hard to find a creative swell. We humans get to go off script. We have the ability and the *gift to stray*. Our lives are not dictated by fixed genetic patterns of behavior. Realizing this, deeply appreciating the wiggle room we are fortunate enough to be born with, should give us some appreciation and invigorate us to take advantage of our evolutionary good fortune.

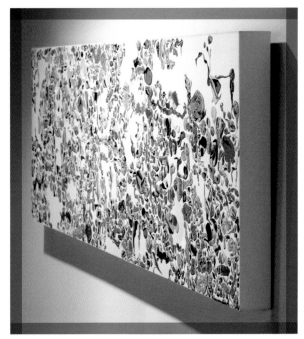

Guten Tags on White

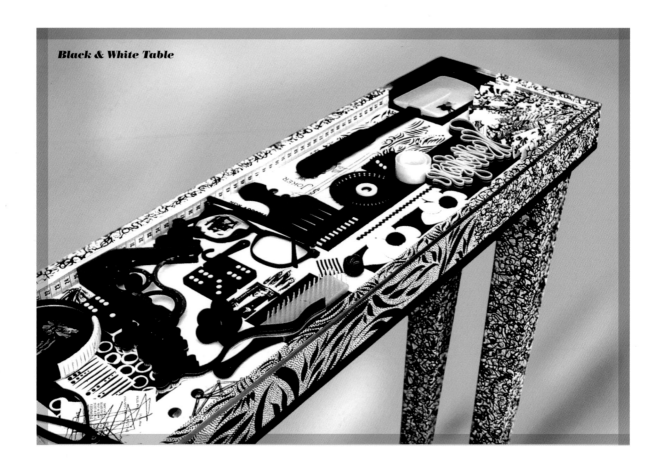

Black & White Table

Understanding the nature of creativity helps us to embrace developing a wide spectrum of ideas—including the unfamiliar, the zany, the seemingly crazy, the never been done before and an appreciation of certain mistakes. You just never know what's going to spawn the germ of a thought that could be developed into something spectacular. And you don't want to cut off any ideas that could ultimately turn out to be the next opposable thumb. If ideas are tamped down in the very early stage when all the potentials are strewn about, the best of the bunch might be left out because of an assumption that "it could never work." **Premature judgments are the antithesis of a creative mind-set.**

Grasping appreciation for the tremendous value in exploring ideas and respecting the function of play is crucial in developing a creative approach to thinking. For artists, it should not only be permission, but a downright insistence on trying out all kinds of possibilities with abandon. It's not just that it's allowed. It's more the case that it's *essential*.

And this same principle of developing and tolerating a wild, crazy spectrum of ideas, again, applies not only to artists, but to anyone interested in creative thinking of any sort. Whether it's about arranging a way to get to the airport or coming up with the next tech sensation, generating and entertaining broad and imaginative possibilities are at the heart of a creative mind-set.

It takes ongoing **practice** to maintain creative thinking.

Soren

THE PRACTiCE OF CREATiVE THiNKiNG

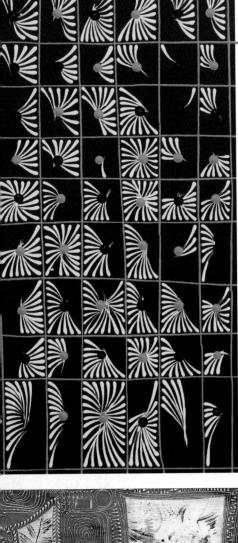

Floracita

We use the word *practice* when we refer to the act of becoming proficient: We practice a musical instrument, we practice learning to drive a car or we practice making paper airplanes. We also use the word when we want to deeply integrate ideas: People practice their religion, meditation or mindfulness. It's standard "practice" for people to go to church or some sort of regular worship on a weekly basis.

In order to fully assimilate new ideas and weave them into our fiber, we need to train ourselves by regularly revisiting concepts over and over. Practice accompanied by some sort of experience embeds ideas into the very structure of our beings. We need to think regularly about these profound ideas that affect the deepest parts of ourselves. The same is true of creative thinking; it's something we need to perpetually practice.

Thinking for ourselves by developing the muscle of genuinely relying on our own opinions and not feeling obligated to please authority figures definitely requires vigilance. Understanding the value that mistakes bring to creativity and being able to integrate that thinking into our everyday experience takes deep practice. It even takes practice to feel the internal permission to let ourselves play freely—to try things out, allow ourselves to be silly and at times to do stupid things and not feel guilt or shame. A lot of effort is required to maintain creative thinking.

The good news is that you can determine for yourself the best methods for finding an individual and meaningful creative trail or practice that will be effective for you. The difficult news is that it's hard work and there's really no great shortcut. But, ultimately, all the hard work, self-doubt, misery, mess and heartache will be worth it. Finding your creative core is among the greatest gifts you can give yourself; it's just that you can't pick it up on your way home from work. You have to trudge through a lot of territory on your own to find approaches that fit you well. Those findings may vary as your own growth alters with time.

Developing acumen with creative thinking doesn't come from reading any single book or following any prescribed set of steps. It's not like learning a new recipe. We need to engage regularly with these ideas because outside pressures seep in and can easily derail us from our initial intentions. **Living creatively is about fundamental, internal recalibrating. And it's an ongoing practice.**

Gray

Please visit createmixedmedia.com/the-art-of-mistakes for bonus content.

Tig

FORMULAS FOR CREATIVITY VS. THE PRACTICE OF CREATIVITY

Much is written about methodology to deliberately enhance creativity. Specific instructions may be given, such as: Be sure to alternate two hours of work with an hour of a restful activity; find music to use when you're working creatively; set aside a special place where you can be creative and on and on.

Although many ideas about how to get the creative juices rumbling may be extremely helpful, it's important—really vital—to remember that everyone is different. In the same way that each artist must follow his or her own aesthetic sensibility, recognizing individual strengths, the way we work also varies from one person to the next. Despite what some may lead you to believe, there are no universal, step-by-step formulas that will deliver everyone to the promised land of creativity. It's different for different people.

CREATIVITY: RUTH NOLLER'S FORMULA

Of all the rather scientific approaches to creativity, this one always seems to me to have a very useful perspective.

Ruth Noller, a pioneer in the field of creativity studies, believed that creativity requires, in some measure, three essential ingredients:

- Imagination is vital in coming up with new ideas.
- Knowledge of the situation or problems we're working with will guide our direction.
- Evaluation is our ability and skill in making choices about what ideas we can discard and what's worth keeping and pursuing.

We often envy the imagination of young kids. They haven't yet been bombarded with all sorts of information or education that might stymie their wonderful creative swell. However at some point, broadening our knowledge (be it more sophisticated materials or familiarity with challenging problems) is appropriate, healthy and desirable. The trick is to maintain the imaginative muscle while greater understanding develops in other areas, such as the skill of making evaluations.

With Red Edge

Just when you think you may have had your last good idea, that your glory days are behind you and creatively, you're as dry as a bone—cheer up. What you're experiencing as dramatic paralysis may actually be an essential part of the creative process. It's called incubation.

Among the many different ways of looking at and thinking about creativity, some models consider "incubation" to be an integral part of how it all works.

Below are some of the terms that are used in a variety of combinations to describe various parts of what I'll call "the creative arch." Many of them have overlapping meanings:

Inspiration: the stimulation of a flowing of ideas.

Preparation: collecting ideas and/or source material.

Incubation: a seemingly dormant period, but one in which disparate ideas are "working behind the scenes" to come together and form new ideas and solutions. The forming of connections between ideas and concepts that were previously unconnected is the fundamental principle in creativity, and that's as likely to occur when we're fast asleep as when we're fully conscious.

Illumination: when all the idea pieces come together and allow things to move forward.

Clarification, Distillation, Evaluation: refining ideas, narrowing the choices, often making tough decisions.

Perspiration, Implementation: the hard work of actual "doing."

I have enough years behind me to remember so many times when I sank into despair, thinking it was all over artistically, that the curtain had come down on my creative life, only to miraculously find that, eventually, the gears got back into motion. Before I understood about **incubation**, I just thought of it as **suffering**. A slight shift in perspective here really makes all the difference.

Thinking of this step as part of the process rather than a ride to the edge of the cliff is, for many, a dramatically different way of looking at how work works. Not only should it inspire you not to panic, it's even better than that: It's understanding that this period of incubation is often part of what has to happen for ideas to fully blossom.

More than just a "hall pass," this is a formal invitation to sit back, relax and enjoy the fact that next time you feel you've hit a wall, you might just unwittingly be going through one of the most salient—and magical—parts of realizing your creative self.

Please visit createmixedmedia.com/the-art-of-mistakes for bonus content.

Passion

Certainly the social science of creativity ushered in a long overdue democratization of the notion of creativity. The discipline continues to look at a wide variety of conditions that promote or discourage a creative climate. And while modern evolutions in attitude are certainly a most welcomed direction from ancient perspectives, an appreciation for magic, mystery and passion as part of the creative force are still essential components that may not be measurable in scientific settings. I believe any discussion on the subject of creativity that doesn't include the concept of passion is ultimately flawed. **Creativity can't happen without some sort of passion.** (Consider the role passion plays in creating new beings.)

Karmen

Creativity, Ethics & Empathy

Creativity, while we like to think of it as always good and wonderful, isn't necessarily a positive force.

When we think of being creative, the tendency is to think about great bursts of artistic splendor, clever story lines with surprising plot twists or brilliant technical advances.

But history is full of extremely creative yet horrendous characters. It's painful to realize that the Nazis as well as the September 11th terrorists were all remarkably creative. The phenomenon of creativity is neither inherently good or bad. Creative ideas can cause devastation just as much as they can bring tremendous progress for society.

Creativity is a tool, a muscle that can be encouraged, nurtured and developed. But creativity is not an end point in itself. As with a car, the destination is up to the driver. When you think about the notion of raw creative muscle, the ability to come up with something new or unique, the Ku Klux Klan is actually a pretty creative bunch. Not just run-of-the-mill vigilantes and killers, they've really devised their own model,

Tivoli

a brand if you will, with a roster of signature symbols and activities potent enough to have attracted and inspired others to act boldly. The creative infusion they bring to their vile inclinations significantly advances their goals.

Like it or not, the reprehensible leaders of this type of lunacy are significantly creative beings. Reviewing just about any assortment of your "favorite" real-life monsters, you're bound to discover common denominators of traits we regularly associate with creative behavior: inventive, different, new, innovative, clever, etc. It's not exactly what most of us have in mind when working to enhance our creativity.

Without a much more comprehensive vision, creativity can be a loose canon. The ideal involves a potent dose of directionality—a moral value—in order to be a fully synthesized goal. Whether this kernel comes from religious doctrine or ornery, independent ruminations, **creativity without empathy is perilous.**

Incorporating evolved moral awareness along with imaginative thinking is a crucial step. With all the stunning creative progress civilization has achieved, it's hard to fathom that, so often, the end game is still about annihilating our enemies. It's time to bring the discord between our potential for imagination and our often rudderless navigation into much sharper focus.

ARTiSTS MAKE THE MOST OF THEiR AVAiLABLE RESOURCES: HOW LiMiTS HELP

Making the most of available resources is a potent way to think of what it means to be an artist or creative in some sense. The combination of eggs, butter and onions can have wildly different results depending on the creative thinking of the cook. In fact, limited resources can drive or inspire us to come up with new, creative ideas.

Living in a part of the world where people have access to just about any sort of materials they can afford is both a blessing and a burden. Having everything in the world at your fingertips isn't necessarily an advantage.

Contrary to what may seem to make sense, an endless array of materials might seem fabulous initially, but it can actually inhibit rather than enhance creativity. Being forced to work with limited resources tends to produce a basic form or foundation for working. You might say that limits create a form the way that walls create a room.

Ultimately, struggling within those limits is where the creative surge—the passion—is ignited. Designs, plans and patterns are all forms or springboards for creative work. Imagination brings vitality to forms.

Tar Tar

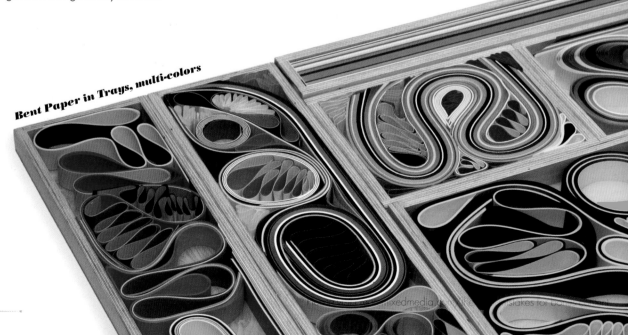

Bent Paper in Trays, multi-colors

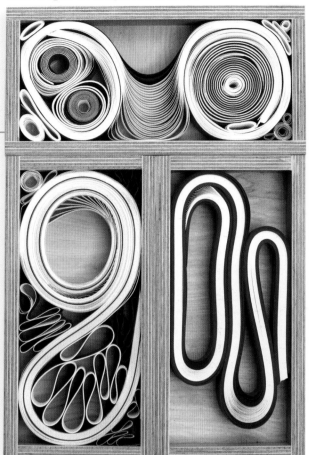

Before you can make the most of your resources, it helps to realize just what all your resources might be. Taking an inventory of your available resources is a good first step that can be illuminating and help you take advantage of valuable strengths you may have taken for granted or overlooked:

First there's your stuff:
• art supplies: paints, brushes, paper, etc.
• scraps: fabric, paper, buttons, etc.

Maybe you have a piece or two of special equipment:
• a table-sized paper cutter
• a laminating machine
• a sewing machine

Maybe you live someplace where you have access to:
• leaves
• stones
• flowers
• lots of water or sunshine

Maybe you have a neighbor or friend who:
• is a cabinetmaker and will share scrap wood with you.
• is emptying out a house or business and has some castoffs that you could experiment with.
• is in the printing business and can bring home reams of paper from bad print jobs.

Whatever the particulars of your situation might be, it's worth stretching your circle a bit to consider some of the resources within your grasp which might not be obvious at first.

Then there are your own particular individual qualities. Maybe you have:
• a wonderful color sense.
• a great capacity for attention to detail, like my daughter who's ability to do extremely intricate work allows her access to a distinctive range of possibilities.
• your own, very individual way of looking at things in general.
• a propensity for finding other uses for trash.
• a comfort level with diving into new projects.
• a particular knack with scissors (or some other tool).

Taking an account of your particular stockpile of resources, in whatever form, is a valuable effort.

Making the most of available resources could just about be a definition of creativity itself.

ART CAN BE POWERFUL STUFF

When you make a piece of art, you never know what it might mean to someone at some point.

I found a self-portrait of my father that I never knew existed . . .

I keep thinking . . . what if on the night he made this, someone had whispered to him . . .

Myron portrait 1950

This self-portrait you just made will be found at the bottom of a drawer sixty-three years from now, by your yet-to-be-born daughter, whom you won't even know for another seven years. When she discovers this drawing, she'll be fifty-six and you will have been dead for twenty-two years. When she comes upon this paper, it will speak to her in a language that can transcend time and place and rational judgment. It will communicate in the language of art.

Please visit createmixedmedia.com/the-art-of-mistakes for bonus content.

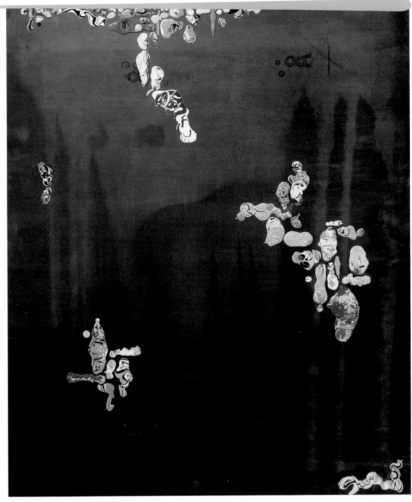

Pohn'J

Creativity is the mechanism human beings use to define themselves—it is the opportunity to be fully human. We each start with a different set of resources based on all the particulars of when and where we're born. What we choose to do and to make with our available resources during our lives leaves a story of who we were in life.

Artists hold up that essential part of the "tent" that keeps creativity alive in society.

Being creative, having ideas that may seem weird or odd or bold, is the offering that artists bring to the world. A culture that can tolerate creative input will be open to making necessary changes for vital growth and development. Societies that aren't tolerant of creative thinking cut themselves off from evolving and staying vibrant.

Next time you feel silly or stupid or ridiculous because of something you did or want to do with your art, remember to go forward with your head held high, knowing that this kind of thinking isn't foolish at all. In fact, it's essential. And it's your calling to keep that flame alive.

It just may be the case that **art is there to remind us that we can think for ourselves.**

John Michael Kohler Arts Center. Sheboygan, Wisconsin: Spectacular museum of outsider and self-taught art.

Watts Towers. Los Angeles, California: An icon of outsider art—99' high towers of metal, tile and glass, built over a period of 33 years by Simon Rodia.

NIAD—National Institute of Art and Disability. Richmond, California: Art studio for developmentally disabled adult artists. Gallery open to the public.

Molten Metal Works. Los Angeles, California: Welding shop offering classes and open studio hours.

Local craftspeople/tradesmen: carpenters, tile layers, picture framers, welders, auto mechanics, etc. Often a wonderful resource for finding free or inexpensive scraps which can be fabulous materials for art making.

Flea markets, swap meets, garage sales, etc.: Developing a keen eye in deciphering useable gems is an important skill.

Side-of-the-road trash: Everything applies as in the above, but it's free!

Craig's list FREE: What shows up for free on Craig's list is sometimes astonishing. Check it regularly for all sorts of items you can use for art-making.

Home Depot (or big hardware stores) often sell quarts and gallons of paints which have been incorrectly mixed at a huge discount. It's a great place to get materials you can use with abandon.

Smart and Final or other restaurant supply stores: These stores carry lots of things that can be used in art making such as rolls of butcher paper and wooden skewers. Also, go through the aisles and be on the lookout for other non-traditional art supplies.

ABOUT THE AUTHOR

After many years of supporting herself as a self-taught artist, Melanie Rothschild decided it was time to take a "proper" art class. After the first night, she realized how fortunate she'd been to have not taken one sooner—recognizing the profound gift which can come from independently forging a creative path. Rather than formally studying art, Melanie has a master's degree in the Study of Creativity. She considers moxie, an irreverent nature and respect for mistakes to be the essential tools of her trade. Her elaborately painted picture frames, boxes and tables were sold for almost two decades in stores and galleries throughout the United States. Her fine art is shown regularly in group and solo shows and is in both private and corporate collections. Find Melanie online at melanierothschild.com.

DEDiCATiON

To Larry, who's learned the art of living with my mistakes.

ACKNOWLEDGMENTS

All that I write, make, do or say is in some respect a result of everything which has gone into my experience in life. These acknowledgments are an overview, some of the highlights of the ingredients which have gone into me being me.

Other fine North Light Books are available from your favorite bookstore, art supply store or online supplier. Visit our website at fwmedia.com.

18 17 16 15 14 5 4 3 2 1

DISTRIBUTED IN CANADA BY FRASER DIRECT
100 Armstrong Avenue
Georgetown, ON, Canada L7G 5S4
Tel: (905) 877-4411

DISTRIBUTED IN THE U.K. AND EUROPE
BY F&W MEDIA INTERNATIONAL LTD
Brunel House, Forde Close, Newton Abbot, TQ12 4PU, UK
Tel: (+44) 1626 323200; Fax: (+44) 1626 323319
Email: enquiries@fwmedia.com

DISTRIBUTED IN AUSTRALIA BY CAPRICORN LINK
P.O. Box 704, S. Windsor NSW, 2756 Australia
Tel: (02) 4560 1600; Fax: (02) 4577 5288
Email: books@capricornlink.com.au

ISBN 13: 978-1-4403-1171-0

EDiTED. **Amy Jones**
DESiGNED. **Brianna Scharstein**
PRODUCTiON COORDiNATED. **Jennifer Bass**
PHOTOGRAPHED. **Larry Garf**

metric conversion chart

CONVERT	TO	MULTIPLY BY
Inches	Centimeters	2.54
Centimeters	Inches	0.4
Feet	Centimeters	30.5
Centimeters	Feet	0.03
Yards	Meters	0.9
Meters	Yards	1.1

KEVIN MORAN	LERS	LITTLE TOOTH	EZRA WERB	YA YA MILAN	MAYURA LUONG	SHIRL BUSS
CARRIE VEHR	CHELSEA GREEN	THE 10's	TONIA JENNY		JAMIE MARKLE	
			PIEMAN		LEON GONZALES	
MEGAN LANE PATRICK			BARNSDALL PARK	AMY JONES	SHAWN METIS	LESLIE STONE
	MOM	LEPIDUS				J.S. BACH
PAUL DAHMEN	LAURA PARIS		HOLLY BROWDE	JULIA FORDHAM	BRIANNA SCHARSTEIN	HANKIE
MARY MURDOCK	NORMA IBARRA	DAISHEY	DREW MEDVEZ	CYNDI BURNETT	JUDY BLINICK	
JANICE BERGEN	TRACY RANE	THE SURROGATES	JACQUELINE KRONBERG	RUSS SCHNECK	LEE ANNE WHITE	THE FABERS
THE SUZY'S	KIRSTY CONLIN	ALL THE BON BONS	AINHOA OTAEGI	MICHELE BRADLEY		
GERARD PUCCIO	FAYE ZUCKER	TOPANGA MOUNTAIN SCHOOL	TRUDI SIPPOLA	FELICE TILIN	VALLEY KINDERSCHUL	FRESH PAINT
I.C.S.C.	DARYA FARHOODI	POHN'S	JOSETTA SPLEGIA	HELENE BROWN	JOO JOO + NAN	
ADELE COUSIN	VICTORIA STEVENS	ERIKA TAYLOR	THE KENNEY BOYS	BRAND LIBRARY	LILL + STEVE	DOUG RINDT
KIRSTY		MEREDITH MAC KEIGAN	RIC DELIANTONI	RAUL ZEVALLOS	MY DEAR INEE	KELLY and EVE
MARION c REVIVAL	BUCKMINSTER FULLER	EVAN O'BRIEN	LAURA LEE BAHR	CURTIS + SUE MENG	CHRISTINE POLOMSKY	ARLENE TASLITZ

iDEAS. iNSTRUCTiON. iNSPiRATiON.

Visit CreateMixedMedia.com/the-art-of-mistakes for bonus demonstration videos and interviews with Melanie and artists talking about mistakes.

Find the latest issues of *Cloth Paper Scissors* on newsstands or visit shop.clothpaperscissors.com.

 Follow Create Mixed Media for the latest news, free wallpapers, free demos and chances to win FREE BOOKS!

These and other fine North Light products are available at your favorite art & craft retailer, bookstore or online supplier. Visit our websites at CreateMixedMedia.com and NorthLightShop.com.

Visit artistsnetwork.com & get Jen's North Light Picks!

Get free step-by-step demonstrations along with reviews of the latest books, videos and downloads from Jennifer Lepore, Senior Editor and Online Education Manager at North Light Books.